DRAGONART

How to Draw Fantastic Dragons and Fantasy Creatures

J "NeonDragon" Peffer

IMPACT

CINCINNATI, OHIO

www.impact-books.com

ACKNOWLEDGMENTS

I'd like to thank the following people for helping to bring this monstrosity to life. Lo, you've helped to unleash doom upon the masses, carried within the brightly colored pages of this seemingly harmless tutorial book:

Alex Kolesar, Christy Pasqualetti, Will Sebree, Joseph Kovell and Mindy Timpone, for patiently listening to me whine, moan and ramble incoherently about deadlines that were looming over my head. Your free counsel was…cheap…and um…invaluable!

Mona Michael, for calling, e-mailing, and nagging the artwork and text out of me. If not for her, this book probably wouldn't be in your hands nearly as soon as it was. (She makes me sound smart!)

And of course, Mom and Dad for giving birth to me, raising me, and throwing me—tenderly—out into the world.

Other fine IMPACT Books are available from your local bookstore, art supply store or direct from the publisher.

21 20 19 25 24

DISTRIBUTED IN THE U.K. AND EUROPE BY DAVID & CHARLES
Brunel House, Newton Abbot, Devon, TQ12 4PU, England
Tel: (+44) 1626 323200, Fax: (+44) 1626 323319
E-mail: mail@davidandcharles.co.uk

EDITED BY Mona Michael
DESIGNED BY Wendy Dunning
PRODUCTION ART BY Kathy Gardner
PRODUCTION COORDINATED BY Mark Griffin

METRIC CONVERSION CHART

To convert	to	multiply by
Inches	Centimeters	2.54
Centimeters	Inches	0.4
Feet	Centimeters	30.5
Centimeters	Feet	0.03
Yards	Meters	0.9
Meters	Yards	1.1
Sq. Inches	Sq. Centimeters	6.45
Sq. Centimeters	Sq. Inches	0.16
Sq. Feet	Sq. Meters	0.09
Sq. Meters	Sq. Feet	10.8
Sq. Yards	Sq. Meters	0.8
Sq. Meters	Sq. Yards	1.2

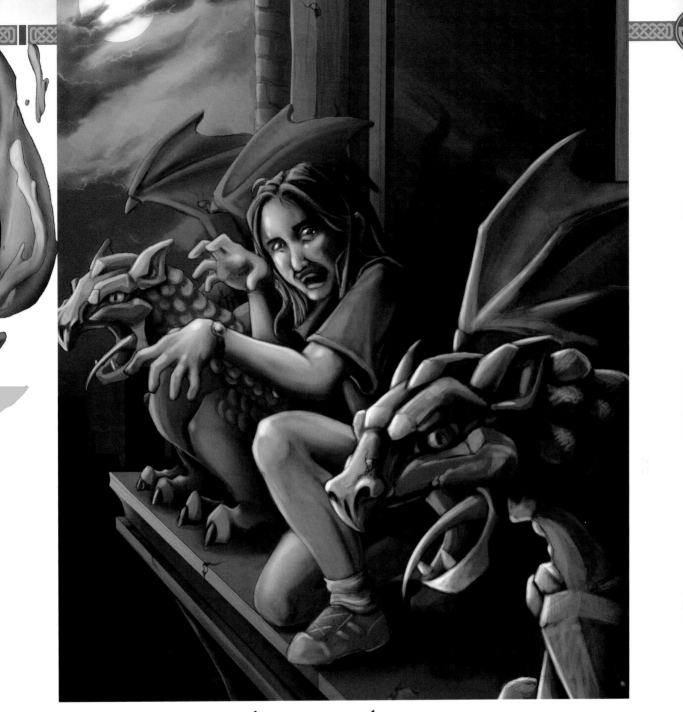

ABOUT THE AUTHOR

J "NeonDragon" Peffer (a.k.a. Jessica Peffer) just finished her senior year
at Columbus College of Art and Design. She hopes to someday work as an illustrator in
the fantasy market full-time—silly dragon…er…girl. Neon has
had her work in print since 2002 when a few little spiffy fairy knick-knacks from Raven
Images launched her into the published world. The paper and
ink that you hold in your hands—feel its power, tingly, yes?—is her
current baby. Hold it close, treat it as something precious. Sleep with it
under your pillow at night. This book is full of power!

Neon runs a spiffy-keen website at www.neondragonart.com
(you're writing this down, yes?) on which she shares her art, online
comics and a few computer art tutorials. It's snazzy, and sure to take
up a good seven minutes of your time.

TABLE OF CONTENTS

INTRODUCTION

6

HOW TO USE THIS BOOK

8

PART ONE
Fantastic Dragons
14

Everything you need to know in order to successfully render the king of all mythical beasts. Begin with a basic, no-frills dragon and go on to detailed lessons for creating dragon expressions and body parts. You'll also practice drawing dragons from every angle before creating Western and Eastern dragons of your very own!

PART TWO
Unique Details
72

Horns, tusks, frills, fins, scales, tails, barbs, feathers and fur! Discover the easy tricks and tips that make every creature you create one of a kind.

Part Three
Other Fantasy Creatures
84

Dragons may rule fantasy worlds but they are by no means alone in the alternate universe. Let your imagination guide you as you explore other fantastic beasts using all the skills you learned while drawing dragons. Learn to create everything from the courageous Pegasus to malevolent basilisks. There's always more to create!

Quick Guide to Fantastic Beasts

124

Index

126

INTRODUCTION

If you've picked up this book, chances are good that you love fantasy. Fantasy worlds are fun vacations from the mundane. They're inhabited by some of the most exciting creatures around. Fantasy creatures can't help but be exciting—there are no limits to what they can be. After all, the only rules they must follow are the ones your imagination creates for them.

Nevertheless, most fantasy creatures have deep roots in ancient myths, fables and legends. The phoenix, featured in such books as the Harry Potter series, firmly stands on the Egyptian legend of the phoenix (page 102). And the Chinese story of the dragon's pearl has been repeated countless times in children's literature.

Other creatures are fairly recent creations of very specific world settings. Books such as J.R.R. Tolkien's The Lord of the Rings and video games such as Final Fantasy go to great lengths to create unique creatures and histories.

Modern-day fantasy creatures are sometimes a spin on an old legend. The Sandman comics and Harry Potter books take well-known creatures of mythology and place them in contemporary environments, sometimes tweaking the creatures a bit so that they fit more smoothly into those worlds.

Where the creatures spring up affects how they are drawn. In purely mythological stories you'll probably want to stick closely to the original description of the creature. With a specific world setting, you'll want your creature to look and feel like the others in that universe. With a spin on a legend, you get to do a little bit of both—allow the creature to retain many of its defining characteristics, while blending it into the look of the world you're building.

Take the basics of drawing from the following pages, then use them to create your own creatures. Fantasy is all about your imagination. Give it space—anything is possible.

Now, let's draw some dragons!

How to Use This Book

Dragons and fantasy creatures, by their very nature, have no firm blueprints. In made-up worlds, rules are made to be broken. However, the creatures all share some similar characteristics. Anatomy must be functional. By studying each piece of the anatomy and understanding how it works, you'll learn to build your own beasts.

This book consists mainly of easy-to-follow step-by-step demonstrations. Each new step of each demonstration is denoted in *red*. Following along with the demonstrations will help you draw several different, truly fantastic creatures. Look out for Dolosus, your fierce dragon guide, along the way, too. He shows up here and there to provide helpful tips and tricks to ease your passage.

Begin with a simple line of motion.

Indicate the head, chest and hips with bubble shapes.

>1<

Don't be discouraged if your first efforts don't look exactly as you planned. Everything comes with practice. The more you draw, the better you'll get. Through sheer repetition, your drawings will improve and your own personal style will emerge. If each drawing you make looks a little bit better then the previous one, you're getting somewhere.

So sharpen your pencils, find your softest eraser and prepare your trusty inking pen, and let's go!

Add a snout to the head bubble.

Place the legs under your dragon. If his legs sway too much to one side or the other, it will look like he's about to fall over.

>2<

Dolosus is Your ~~Master~~ Helpful Guide!

Hello, I am Dolosus. Behold my majestic visage and tremble with the proper mix of fear and awe. I shall guide you through the contents of this puny art book.

DRAGON BASIC SHAPES

First things first. Before you can dive into drawing beautiful beasts, you need to arm yourself with some drawing basics. The easiest way to think about drawing anything is to think of everything as shapes. Anything you would ever want to draw—tables, chairs, flowers or unicorns—consists of simple shapes.

BASICS LEAD TO BEASTIES
Practice drawing these simple shapes before moving on to more complicated forms.

DRAWING ANY CREATURE BEGINS WITH BASIC SHAPES
Every dragon or creature you'll learn about in the pages to follow will begin with simple shapes such as these.

TOOLS YOU NEED

The wonderful thing about drawing is that you really don't need much—your own imagination is the most important thing. To get what's in your head down on paper, though, you will need:

SOME PENCILS AND A PENCIL SHARPENER ✦ A KNEADED ERASER ✦ PAPER

That's all that's required to propel yourself into fantasy-creature creation readiness!

Use Basic Shapes to Figure Out Poses

Posing your creatures may initially cause a lot of trouble. They are so complex, with dozens of moving parts.

Take a deep breath and simplify. You can put in details later. Basic shapes will allow you to work out your pose easily. Once you are happy with the pose, you can go back in and fill in all the little details that you want.

DRAGON SHADING AND 3-D EFFECTS

Dragons appear more realistic when you draw them to look three-dimensional.
It isn't as hard as it sounds. You just have to pay attention to darks and lights
and how they affect your creature.

Consider first where the light is coming from. This is called the *light source*. Where the
light source hits your dragon or other object is the lightest spot, called the *highlight*. The
rest of your creature will likely be in some stage of shadow. As you develop your skills at
shading the shadow areas, your creatures will begin to take on new life.

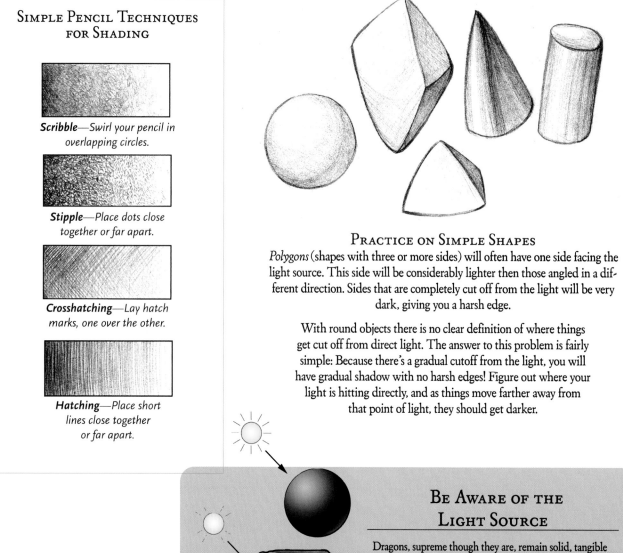

SIMPLE PENCIL TECHNIQUES FOR SHADING

Scribble—*Swirl your pencil in overlapping circles.*

Stipple—*Place dots close together or far apart.*

Crosshatching—*Lay hatch marks, one over the other.*

Hatching—*Place short lines close together or far apart.*

PRACTICE ON SIMPLE SHAPES

Polygons (shapes with three or more sides) will often have one side facing the
light source. This side will be considerably lighter then those angled in a dif-
ferent direction. Sides that are completely cut off from the light will be very
dark, giving you a harsh edge.

With round objects there is no clear definition of where things
get cut off from direct light. The answer to this problem is fairly
simple: Because there's a gradual cutoff from the light, you will
have gradual shadow with no harsh edges! Figure out where your
light is hitting directly, and as things move farther away from
that point of light, they should get darker.

BE AWARE OF THE LIGHT SOURCE

Dragons, supreme though they are, remain solid, tangible
objects that follow the same laws as everything else when it
comes to light source. Lighting that comes from a single
direction will yield highlights on the surfaces that it hits,
and shadows on the areas blocked off from the rays.

PERSPECTIVE AND OVERLAP

Overlap is a great tool for creating *perspective*, the illusion of space, and is arguably one of the more important aspects to creating drawings full of depth. When you draw one object or part of an object overlapping another, the object in front automatically looks closer while the one in the back looks farther away.

You can use overlapping objects to create a sense of perspective not only in individual creatures but also in whole scenes. Draw a mountain, then a house overlapping it followed by a dragon overlapping the house and you've got a foreground, middle ground and background. Once those are clearly defined, you've got a believable drawing.

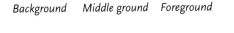

Background *Middle ground* *Foreground*

OVERLAPPING DEFINES YOUR SPACE
Overlapping shapes help clearly define your foreground, middle ground and background and give friendly dragons like this one a clear sense of solidity.

NO PERSPECTIVE OR OVERLAP
Without any overlap or perspective, it is difficult to get an idea of the scale of things. It is also difficult to think of the object as existing within a space. It's lost, floating on the paper.

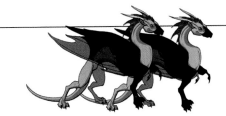

OVERLAP GIVES A SENSE OF ORDER AND GROUND
Overlap provides a sense of space. The brain registers that one object must be in front of the other.

OVERLAP PLUS SIZE VARIATION PROVIDE MORE PERSPECTIVE
The green dragon is smaller than the brown. When we see it though, we don't think he's actually smaller then the brown. We just assume he's farther back in the space that they share.

OVERLAP PLUS SIZE VARIATION PLUS ATMOSPHERE EQUALS PERSPECTIVE TO THE MAX!
Atmospheric perspective means that things that are closer appear brighter, have greater contrast and look more in focus. As they recede, all these effects fade. Using all three perspective techniques gives the viewer a good sense of depth.

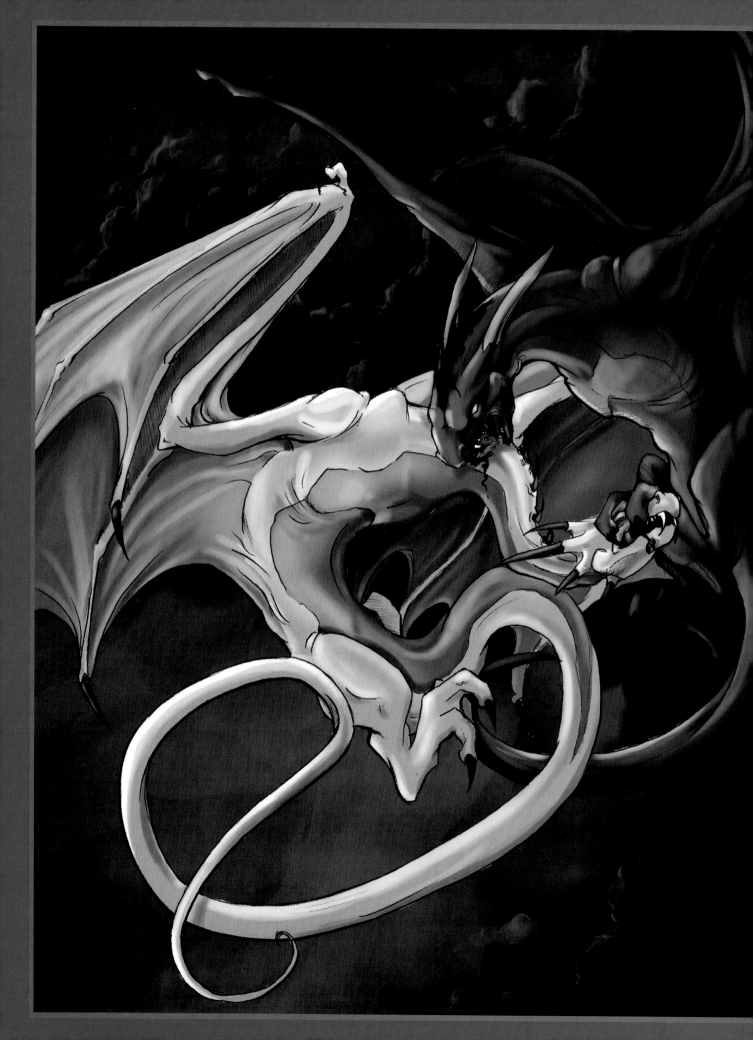

PART 1

FANTASTIC DRAGONS

FANTASY IS DRAGONS.

Dragons are the creatures that capture all the magic, mystique and power of the fantasy realm. They come in all shapes and sizes, all varieties of powers, and in all types of personalities. From the wise, benevolent dragons of the east, to the vain, archetypical dragons of the west, to the new and exciting spin-offs of today, dragons are always magical and always exciting.

Since there is such a variety in what is considered "dragon," there is a lot of freedom in how to draw these mythical creatures. There are also a few common ideas on dragons. This book will help you master these familiar bits and pieces of anatomy so that your dragons on paper are the same as the dragons in your head. Oh...how many dragons there are in my head!

Without further ado, turn the page and let the madness begin!

Begin with a Basic Dragon

The basic dragon consists of a fire-breathing, four-limbed, winged beast. In this project we are going to warm up with a simple profile pose. I'll cover each aspect of the anatomy in greater detail later on. For now, concentrate on getting a creature that is both cool and believable.

Begin with a simple line of motion.

Indicate the head, chest and hips with bubble shapes.

>1<

The chest will usually be thickest, followed by the hips and then the neck.

Add a snout to the head bubble.

Place the legs under your dragon. If his legs sway too much to one side or the other, it will look like he's about to fall over.

>2<

Taper the tail toward its end.

>3<

Flesh out the front limbs. The limbs get smaller toward the claws.

The lower arm will be thinner than the upper, and the thigh will be thicker than the calf, which will be thicker than the ankle.

>6<

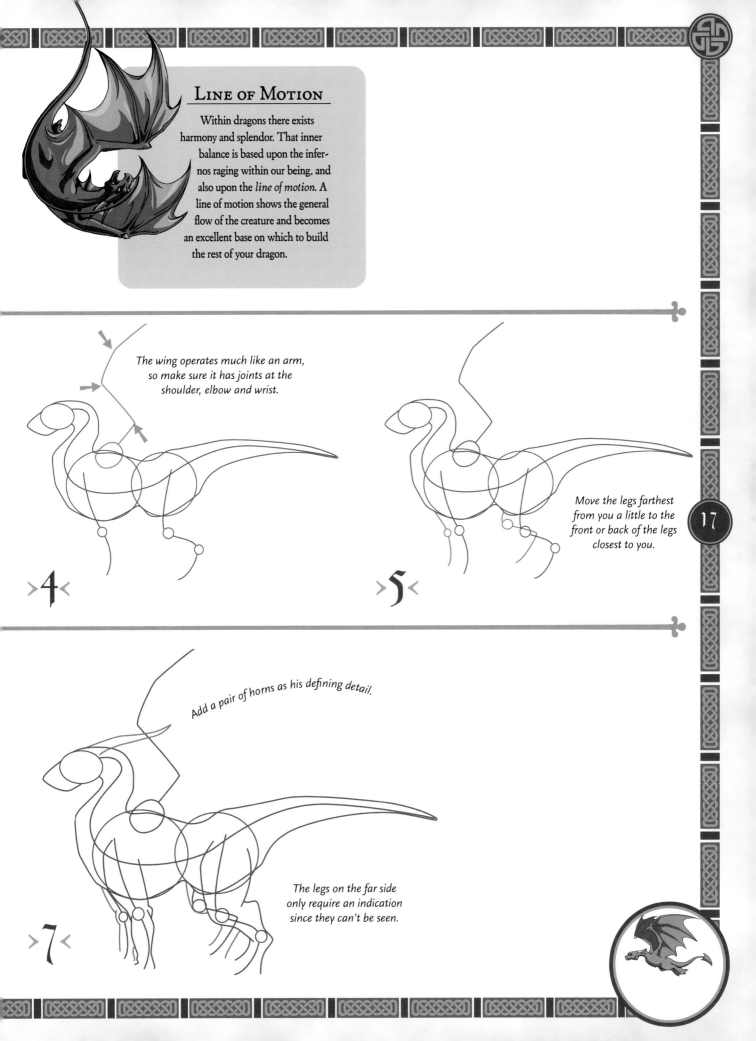

LINE OF MOTION

Within dragons there exists harmony and splendor. That inner balance is based upon the infernos raging within our being, and also upon the *line of motion*. A line of motion shows the general flow of the creature and becomes an excellent base on which to build the rest of your dragon.

The wing operates much like an arm, so make sure it has joints at the shoulder, elbow and wrist.

>4<

Move the legs farthest from you a little to the front or back of the legs closest to you.

>5<

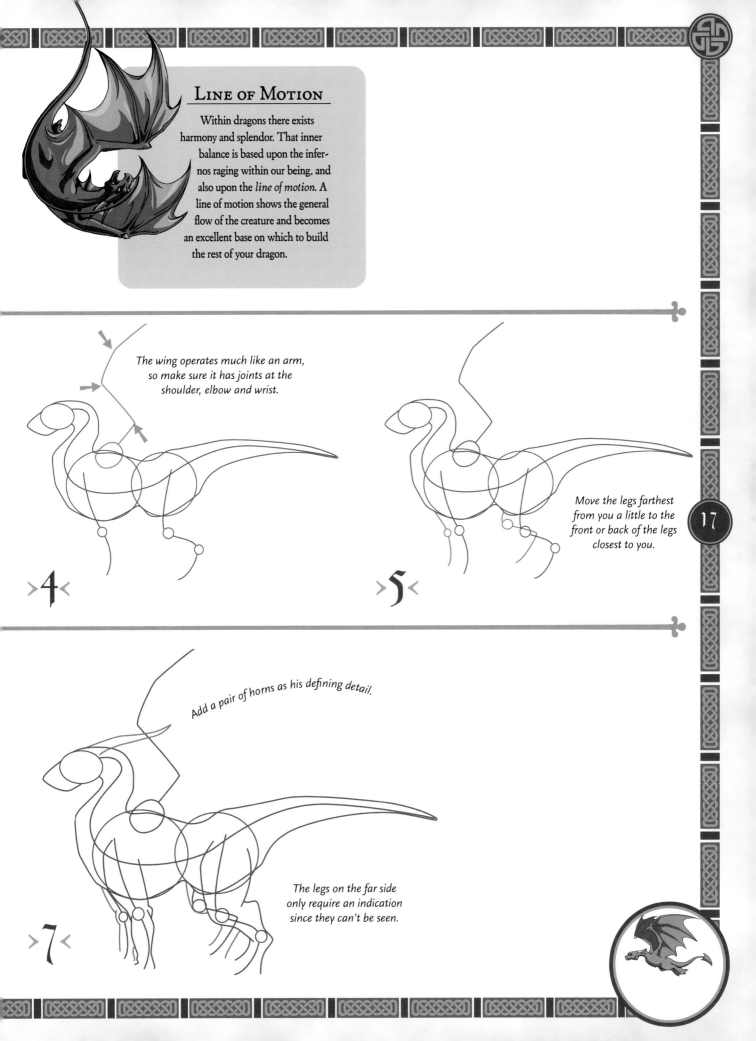

17

Add a pair of horns as his defining detail.

>7<

The legs on the far side only require an indication since they can't be seen.

Lay in the back wing the same
as you did the front.

Fingers bend, and so do the
poles for this sail! Give a
small bend halfway down
each finger to indicate the
knuckle and the ability of
that wing to flex and fold.

Give your dragon something to stand for!
I mean—on! Add hands and larger claw-feet.
Dragon front paws can include fingers and
thumbs, much like a human's.

>8<

>9<

Here's where you really get
to be creative. Add spikes,
frills or claws.

Tighten up the line work and fine details.
Erase the construction lines and admire
your handiwork!

>11<

>12<

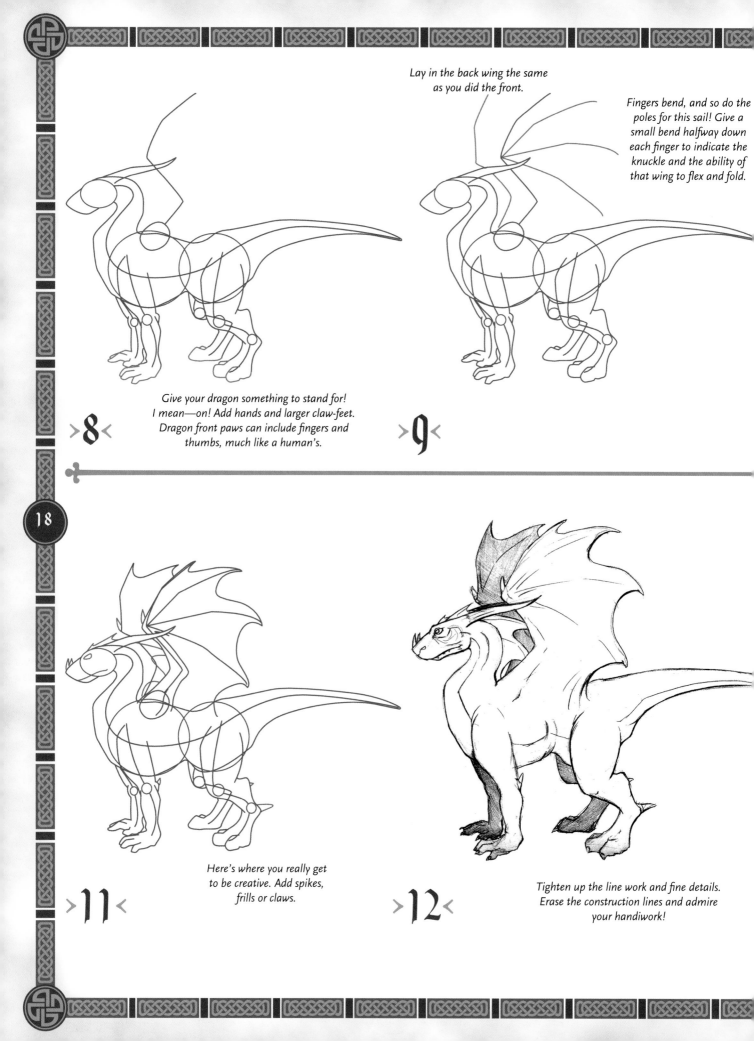

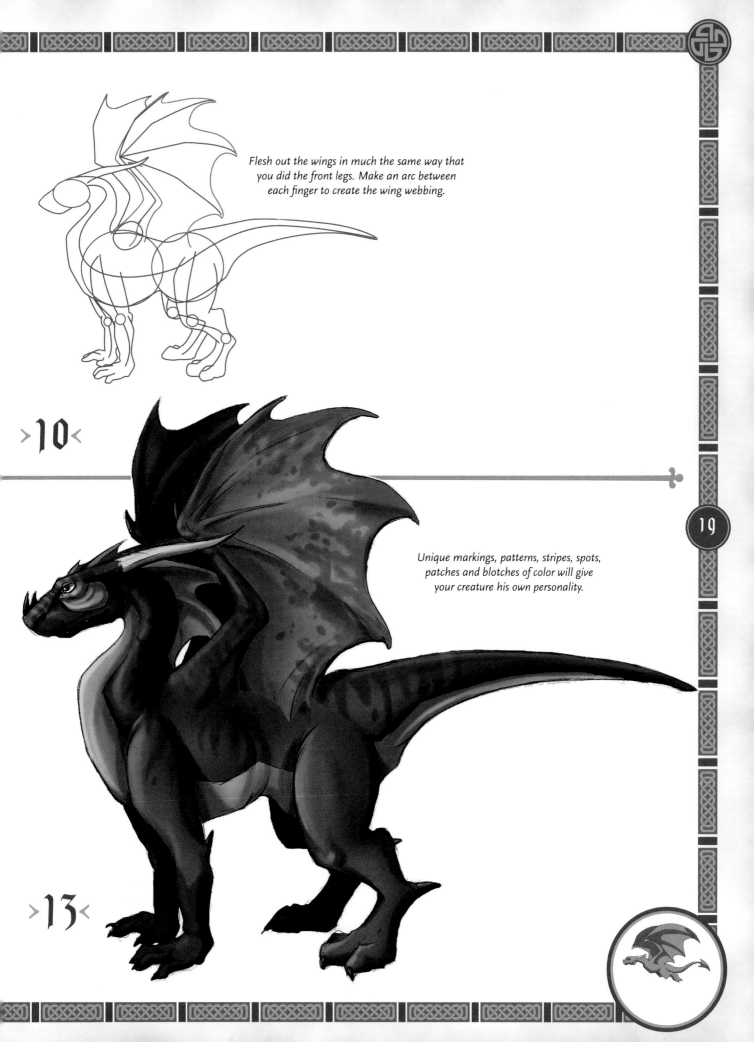

Flesh out the wings in much the same way that you did the front legs. Make an arc between each finger to create the wing webbing.

>10<

Unique markings, patterns, stripes, spots, patches and blotches of color will give your creature his own personality.

>13<

BASIC SHAPES BECOME YOUR DRAGON

The great and terrible thing about dragons is that there is no right way to draw them.
Being creatures of fantasy and magic, they are very crafty at dodging photographers.
So the only way you'll know how to draw a dragon is if you've seen one up close.
Don't try to take its picture though, you'll likely frighten it away. The last
thing any self-respecting *wyrm* (that's just another word for dragon) wants is to end up
on the front of a tabloid at the local supermarket! Instead, cautiously approach the drag-
on, offer it a piece of candy or a little sister, and draw while it happily munches away.

Each dragon you encounter will be just a little different from the next. A good way to
give these unique dragons a definite feel is to work with shapes. You learned
a little bit about how shapes turn into dragons on page 10. Now we'll take that a
step further as you learn how those shapes actually affect the *look* of your dragon.

Triangular Dolosus

Circular Dolosus

Box-Like Dolosus

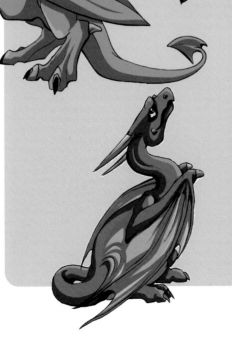

CHANGE THE BASICS, CHANGE THE DRAGON

As you can clearly see, dragons come in many different shapes that will yield
many different feels. Take all of this into consideration when designing your
dragon. A dragon that is going to be used for a birthday card may look very dif-
ferent from a dragon that is being tattooed on the shoulder of a big, burly biker.

Of course, you shouldn't mess with perfection. The perfect balance of shaping
exists here before you. Feel honored that you lay eyes upon my being. And get
these imposters out of here!

CIRCULAR SOFTIES

A series of round shapes will yield a friendly, soft-looking dragon. Repeating the shapes throughout the creature will continue this look. Note: These are the dragons that sit still when fed candy.

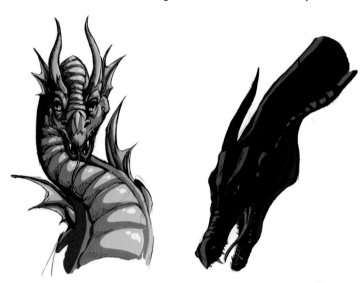

TRIANGULAR TERRORS

Triangles and diamonds will give you a harsher, more evil-looking wyrm. Sharp angles are great for serpentine dragons. Note: These dragons pose best when fed younger siblings.

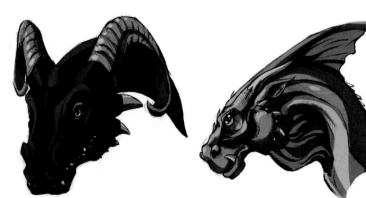

BOX-LIKE BATTLE DRAGONS

Dragons built of boxes are solid, massive-looking creatures. The box shapes give them weight and presence on your paper. If you encounter a dragon that is larger than a house, you may want to use this approach. Note: These dragons won't sit still for any treat smaller than a cow.

DRAGON FACES AND EXPRESSIONS

Drawing a dragon devoid of personality won't be fun for long. Make your dragon a real character by giving it feeling and emotion. How is it reacting to the things around it? What does it want to do? Much of a dragon's expression lies in the eyes and mouth.

EYES SHOW NATURE AND EMOTION
Your dragon's eye and the ridge above the eye (like an eyebrow) are very important parts of its character.

 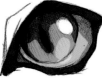

SLIT PUPIL
A slit pupil will make your dragon look more beast-like or evil.

 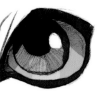

ROUND PUPIL
A round pupil will give the dragon the most warm, intelligent and human-like expressions.

NO PUPIL
An eye devoid of any sort of pupil will look unemotional, detached and alien.

MOUTHS NEED HELP TO SHOW EXPRESSION
Dragon mouths just can't do too much on their own. They open and they close—how do you show expression with this type of jaw? All the emotion of your dragon falls to the area on the edge. Give your dragon a little bit of fleshy lip that it can curl up to show teeth when angry or pull back into a grin when happy.

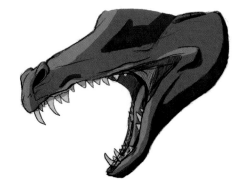

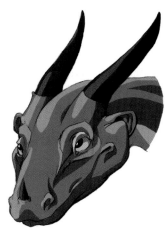

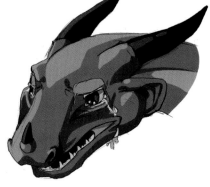

HAPPY DRAGON: "SHE'S DRAWING ME!"

Happy dragons have wide eyes, with raised eye ridges and perked-up ears. Their mouths are slightly open and their lips are curled up in a good-humored grin. It is *very* important to have wide eyes for a happy face. If your dragon wears a grin on its face with angry eyebrows, the dragon will appear to be grinning evilly (another situation entirely).

CYNICAL DRAGON: "I CAN'T BELIEVE SHE'S DRAWING ME AGAIN!"

Pull off a disinterested, cynical dragon by rolling the eyes up into the head, drooping the ears, and pulling the dragon's lips down into a frown. For added disbelief, draw one eye ridge higher than the other, like a raised eyebrow.

SAD DRAGON: "SHE JUST WON'T STOP DRAWING ME!"

A truly sorrowful dragon requires a bit more than tears. Pull the eyebrows up in the center of the dragon's head and give the eyes a little extra highlight to show wetness. Open your dragon's jaw slightly (like it needs a little more air) and pull the lips into a frown.

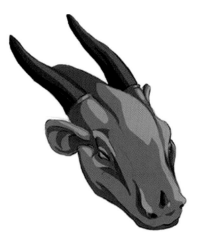

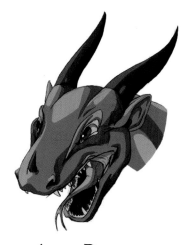

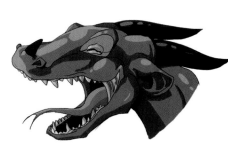

SLEEPING OR EMOTIONLESS DRAGON: "WHEW!"

Sleeping dragons can have a hint of a smile or a frown on their faces; but in most cases they won't have much expression at all. Relax the eyebrows, close the eyes, droop the ears and have the mouth follow its natural lines without any lip accents.

ANGRY DRAGON: "STOP IT ALREADY!"

This little dragon is very angry! The jaw is fully open exposing *all* the creature's very sharp teeth. The dragon's lip curls up in a snarl and the eyes narrow to slits.

LAUGHING DRAGON: "I JUST ATE THE ARTIST!"

A laughing dragon's mouth is wide open to let out the bellow of laughter and allow him to breathe a little harder. Curl the lip into a smile or this wide-open jaw will look like a screaming dragon! He may even be smiling enough to push a cheek up into the eye in a happy expression. Closed eyes show that the dragon is truly laughing hard.

DRAGON HEAD, SIDE VIEW

Now that you've explored some of the types of dragon heads and expressions, put your research to work in creating a basic dragon head from the side. The profile view of a dragon's head is very striking and is a great starting point because there is little to no foreshortening or perspective involved.

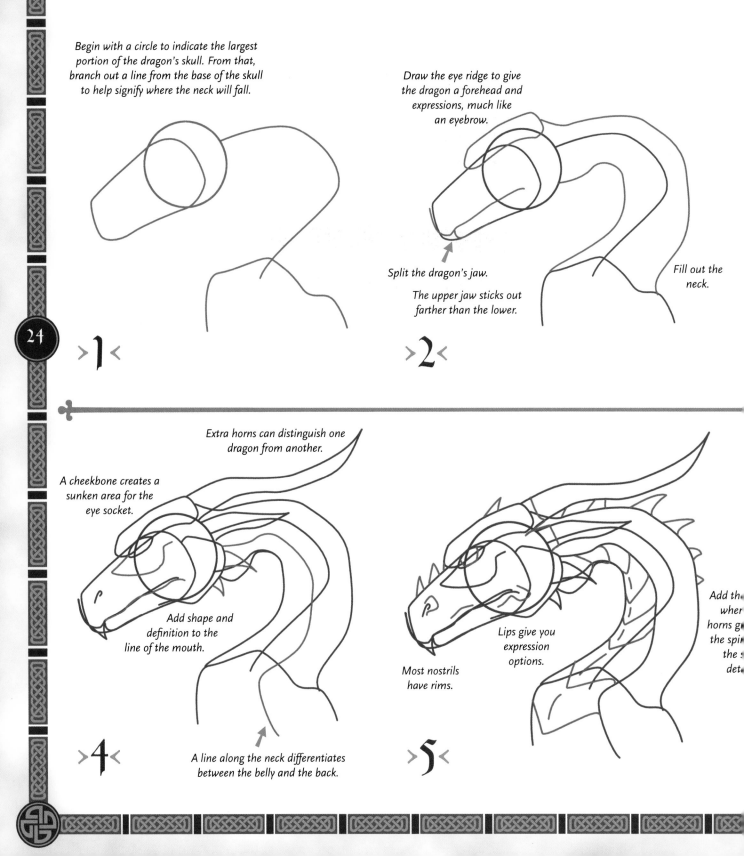

Begin with a circle to indicate the largest portion of the dragon's skull. From that, branch out a line from the base of the skull to help signify where the neck will fall.

>1<

Draw the eye ridge to give the dragon a forehead and expressions, much like an eyebrow.

Split the dragon's jaw.

The upper jaw sticks out farther than the lower.

Fill out the neck.

>2<

A cheekbone creates a sunken area for the eye socket.

Extra horns can distinguish one dragon from another.

Add shape and definition to the line of the mouth.

A line along the neck differentiates between the belly and the back.

>4<

Most nostrils have rims.

Lips give you expression options.

Add th… wher… horns g… the spi… the s… det…

>5<

24

Finish the basics by adding decorative horns or frills.

Fill in the eye.

Beef out the jawline.

Add a sharp beak on the end of the snout, like a bird of prey.

>3<

LINE WEIGHT

Dragons are multi-dimensional, infinitely complex creatures. As such, don't tie us down to the page with weakling line work. Vary the line width to make your drawings come to life. Things with thicker lines will feel like they have more weight while making the objects they encase move toward the foreground. Details may be better rendered with thin lines.

Once you've erased the construction lines and tightened up your line work, you can begin to color. Start with the large areas and work to the small. That way, you can adjust small patches of color to match the big ones.

Charcoal gray horns and vibrant yellow eyes and teeth stand out against the blues.

I colored this dragon's dark violet-blue hide first. The next largest section is the belly. Gray-blue belly scales match the blue of the hide.

>6<

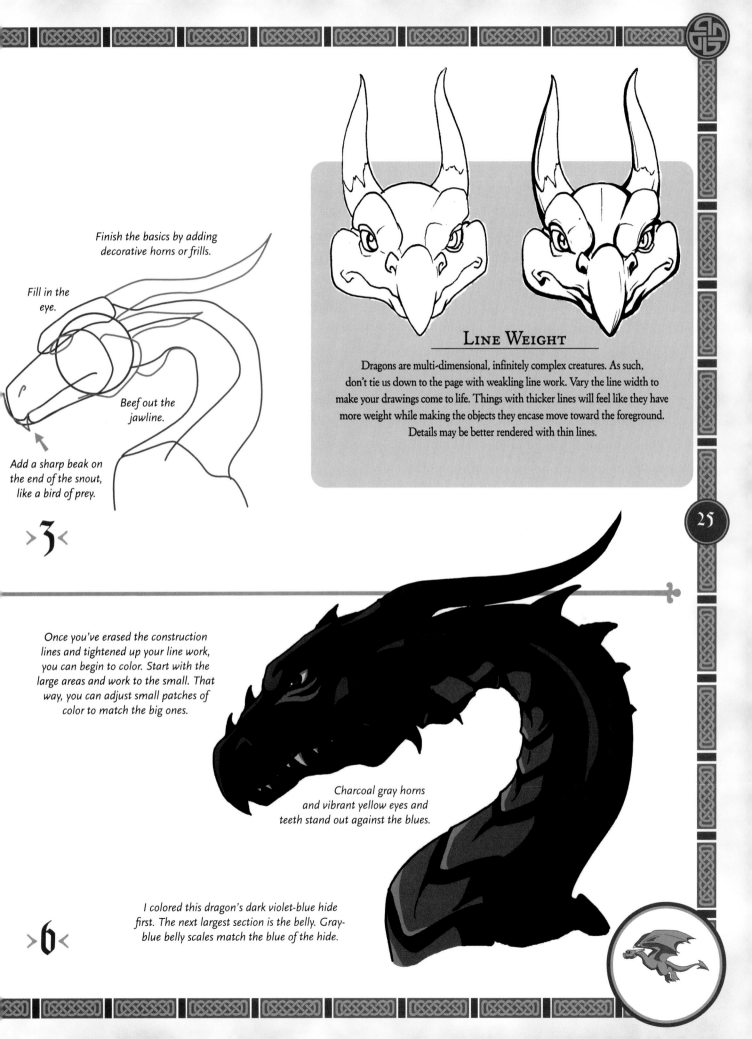

DRAGON HEAD, FRONT VIEW

The dragon's head construction is basically the same from every view. It's merely your perspective on it that changes. The head does not morph just because it's seen at a different angle! Dragon heads from the front view can be more difficult because of the emphasis on perspective and symmetry. The face must be symmetrical. All vertebrates found on earth typically have mirrored sides. And most (but not all) fantasy is based on real creatures and bones found here on earth. If your dragon has a droopy cheek and two eyes on one side, it will look like an alien creature, not something from fantasy.

Use simple shapes to place the head, neck and shoulders.

>1<

SHADING STYLES

Depending on whether you want more realistic-looking dragons or more stylized beasts, you can choose between two different types of shading. *Flat cel-style* shading uses sharp transitions between lights and darks. Highlights are often depicted with sharp whites. *Soft shading*, on the other hand, is, well, soft. It incorporates gradual and smooth transitions from shadows to highlights for a more realistic look.

Soft shading

Flat cel shading

The back of his head is in the background so should recede and look smaller.

Pull out scales, plates, horns, spikes and give form to the rest of the creature.

The dragon's nose is in the foreground. Draw it larger so that it's coming at you.

>4<

The larger the neck, the larger the dragon. Fairy-sized dragons have thin, long necks, while large dragons have thick, short necks.

Define the brow ridges.

Pull out the upper jaw.

Begin details like horns, frills or manes.

Set the eyes behind the brow ridges to make them look sunken into the eye sockets.

Define the lower jaw.

27

When you are done, you can begin erasing the construction lines.

Add your final lines.

For a comic-like dragon, ink your final drawing and fill in your colors in a flat cel-style approach.

Dragons have hard, possibly shiny scales. Do not be afraid to pop in harsh highlights.

Fill in textures and details like wrinkles around the eyes and shadows on the nose.

Highlights and shadows give your dragon form.

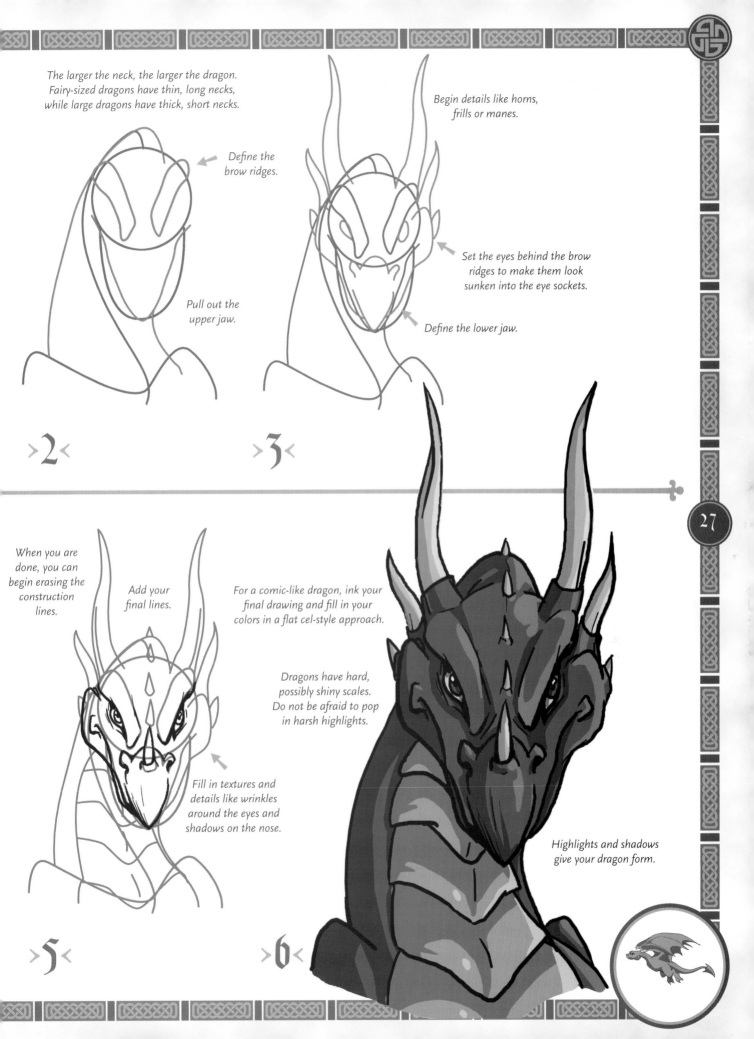

DRAGON HEADS, 3/4 VIEW

The 3/4 view is the most common view to take with a dragon mainly because this view conveys motion. And dragons, when not holed up guarding their treasure, are always moving. It's a little harder to draw the 3/4 view because, unlike the profile, this view displays portions of the other side of the head and it has more complexity than the simple, symmetric front view. Learning this view will give your dragon a more dynamic look, because it gives the impression that he's in motion.

3/4 VIEW FROM TOP AND UNDERSIDE

The 3/4 view doesn't only happen from left to right, it also happens from top to bottom. Try tilting your dragon's head to get a better look at its visage. Remember to include a good portion of the lower jaw and neck on a shot looking from a worm's-eye view, while a bird's-eye view will display more of the skull.

The portion to the left of the shoulder line should be much larger than the portion on the right.

Draw simple shapes for the head, neck and shoulders. One side will have a greater portion of the shapes exposed to you, while the other will recede into space.

>1<

Three frills make this dragon look almost aquatic.

Add any additional spikes or horns.

>4<

Erase the construction lines once you're happy with you drawing.

Add the wrinkle in the frill.

Add lines t front eye ric emphasize roundne

Draw a highlight in the eye and a lip around the mouth.

>5<

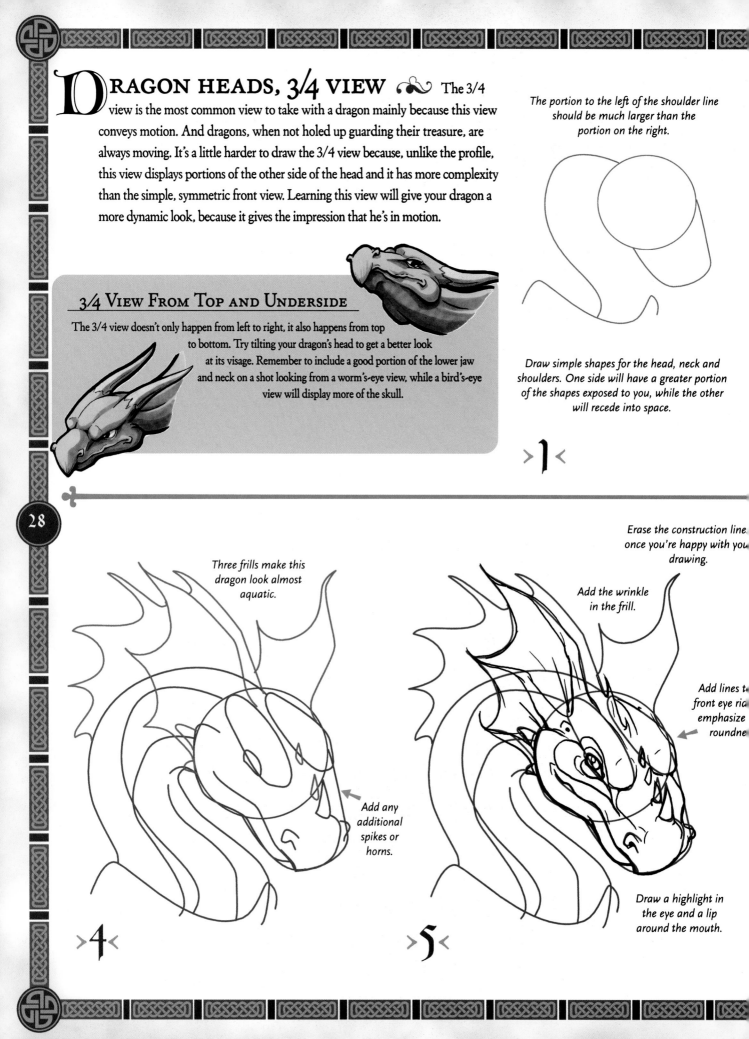

28

Flesh out the neck and transition into the shoulders.

Pencil in the eye ridges, making sure that they curve along the skull for eye sockets.

Set the eyes behind the brow ridges.

Add an upper and a lower jaw.

Define the lower jaw.

Indicate a separate area for the belly.

We are looking down on this dragon's head at an angle. If we were looking up at the dragon's head, the foreground and background shapes would be flip-flopped.

You are not looking at the dragon straight on, so the center of the belly will be farther away from you. Indicate the center of the belly with a third line.

>2<

>3<

>6<

Since this dragon has aquatic frills it makes sense to color it in a bluish green to allow it to blend in with its scenery.
Put several different colors within a single creature to add interest. The skin of the frills is bluer than the main body, while the underside is an aqua.

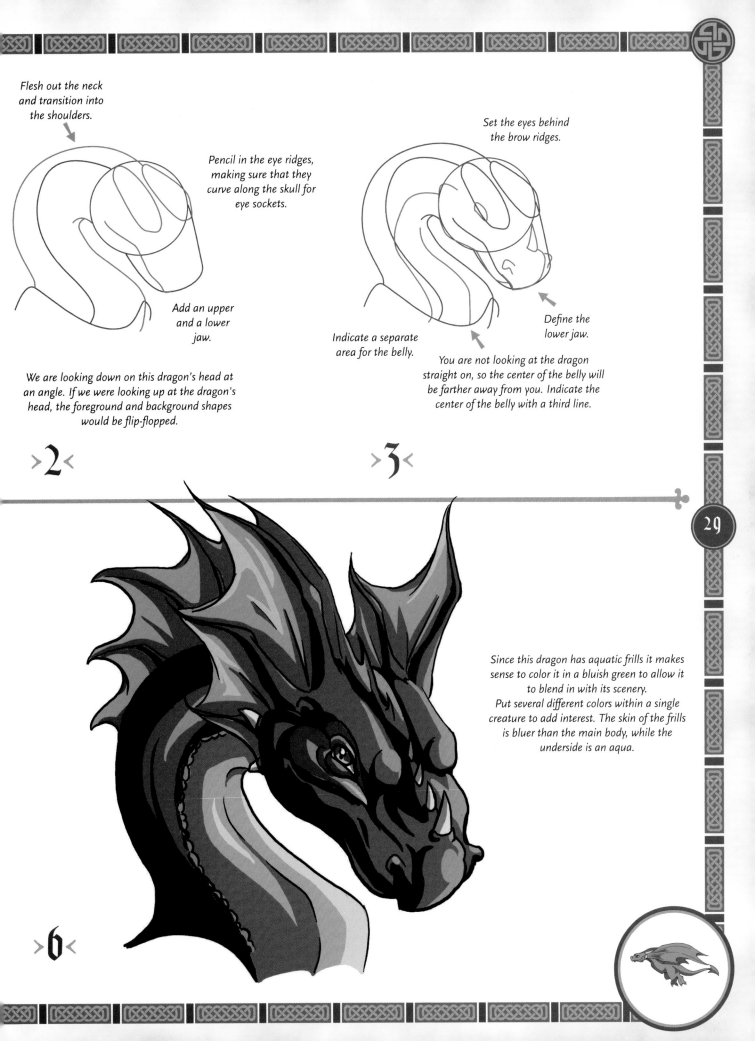

DRAGON LIMBS

Drawing the arms and legs of your dragon can be quite daunting. How do they bend?
How do they work? And, most importantly, how many are there? You have to answer
these questions before you can even begin drawing. The answers to
these questions will determine not only how your dragon looks,
but also how it functions in your world.

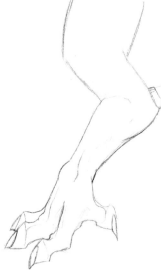

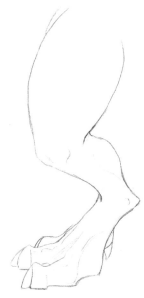

FRONT LIMBS
Front limbs can be either weight-bearing limbs or
limbs that are held above the ground and possibly
used for manipulating objects.

BACK LIMBS
Back limbs will almost always bear weight,
unless you're creating a dragon that walks
on its hands…which might actually be
kinda cool!

THE BASIC APPROACH
A basic design is to give your dragon four legs and
wings on its back, like an animal. This allows for
the dragon to have pretty good balance and ani-
malistic grace, though not a lot of freedom
to use its arms.

BAT-DRAGONS

Occasionally, dragons are like bats, with wings in place of arms. For this you will probably want to make the wings very muscular, so that your dragon can still crawl around on the ground. Placing wings this way makes drawing dragons in flight much easier.

DINOSAUR DRAGONS

Another approach is to have the dragon stand on two legs with wings in the back. This dinosaur-type approach frees up the creature's shorter front limbs and gives it functional limbs that work like hands.

NUMBERS ARE LARGELY IRRELEVANT

Determining how many limbs your dragon has is an aesthetic choice. If you want a sleek, birdlike dragon, two legs and a set of wings do just fine. If you want a more catlike dragon, four legs may be the way to go. A dragontaur with six legs may be neat as well! A dragon centipede with a hundred legs...never mind.

HUMAN-LIKE FRONT LIMBS

You may create a dragon that you want to act more like a person and less like an animal. Giving it human-like arms will help an intelligent dragon get around, read books and build things. These arms are best paired with a set of claws that have opposable thumbs; thus the dragon will be able to pick things up, gesture, and interact with its environment in a more dynamic way. When placing these limbs, consider whether you want your beast to stand upright on two legs or to walk on all fours. If the creature walks on all fours, you'll want to place the claw flat against the ground. You'll shorten the top portion of the limb and lengthen the bottom portion—the one that spans elbow to wrist.

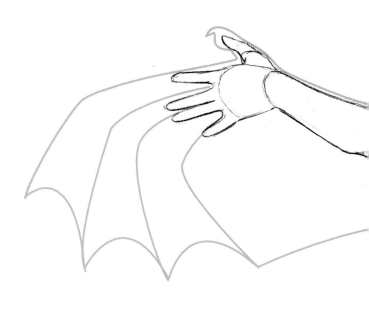

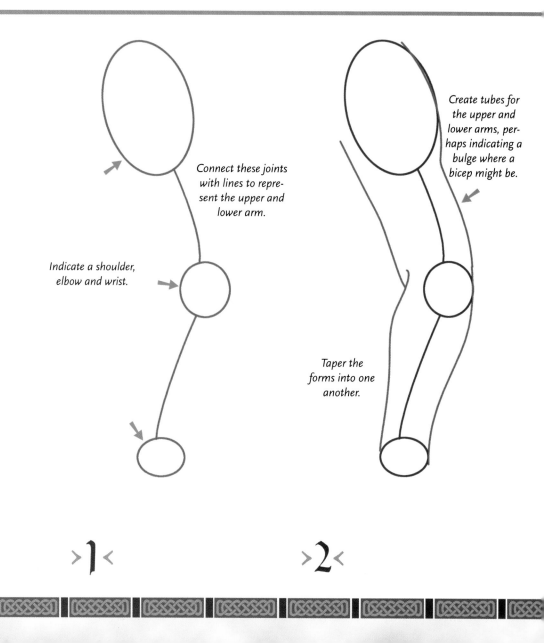

Connect these joints with lines to represent the upper and lower arm.

Indicate a shoulder, elbow and wrist.

Create tubes for the upper and lower arms, perhaps indicating a bulge where a bicep might be.

Taper the forms into one another.

>1<

>2<

Uses for Hands

With these great gripping appendages dragons can read books, count treasure, rest their heads and devour maidens.

Maybe he can pick things up, but I've got all the coolness I can handle packed into this majestic, compact design. Hands are overrated.

Indicate the biceps and forearms further.

Indicate a tiny overlap of skin where the shoulder meets the body.

Add spikes or frills.

Use thinner lines along less important shapes.

Use a light, delicate touch for the barely perceivable curve of muscle.

A medium line weight works best for the individual scales.

Emphasize the edges of the major shapes of the upper and lower arm with thick, dark lines.

Use strong highlights to make your dragon's hide glossy and metallic.

>3< >4< >5<

ANIMAL-LIKE FRONT LIMBS

If your dragon is not intelligent and is just a really awesome creature, it probably won't need hands to manipulate objects like a human's would. You may want to think abut using animal-like front limbs to give your dragon something it can use to...oh...rip up some knights or deer or something. Animal-like front limbs almost always make the creature appear less human.

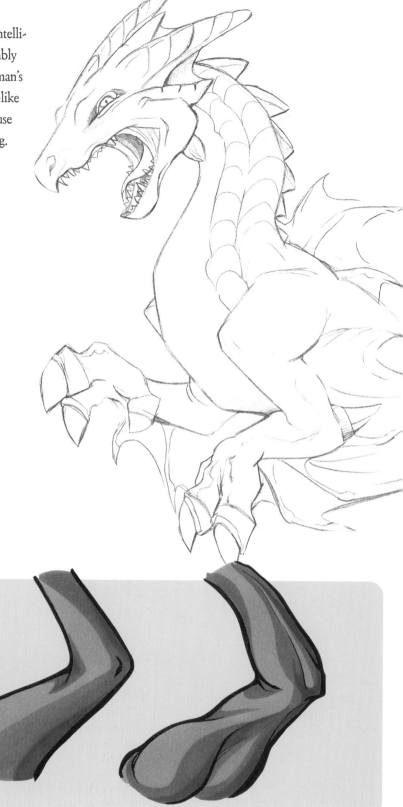

DRAGONS ON STEROIDS

Doing an arm or a wing without any anatomy detail will leave your creature looking flat. Add biceps, triceps, dragonceps, awesomeceps and excessiveceps to make your drawing pop off the page.

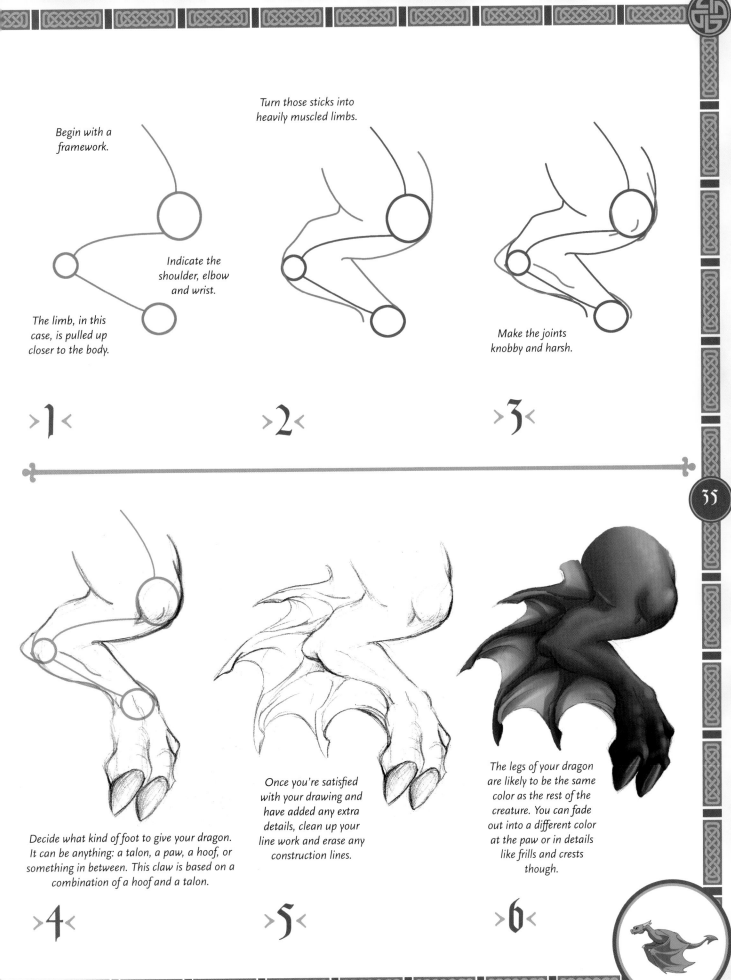

Begin with a framework.

Turn those sticks into heavily muscled limbs.

Indicate the shoulder, elbow and wrist.

The limb, in this case, is pulled up closer to the body.

Make the joints knobby and harsh.

>1<

>2<

>3<

Decide what kind of foot to give your dragon. It can be anything: a talon, a paw, a hoof, or something in between. This claw is based on a combination of a hoof and a talon.

Once you're satisfied with your drawing and have added any extra details, clean up your line work and erase any construction lines.

The legs of your dragon are likely to be the same color as the rest of the creature. You can fade out into a different color at the paw or in details like frills and crests though.

>4<

>5<

>6<

DRAGON HINDQUARTERS

The back legs of a dragon are a bit different from the front, but just as important. Make sure you know the proper bends and sizes so that your dragon looks natural and believable.

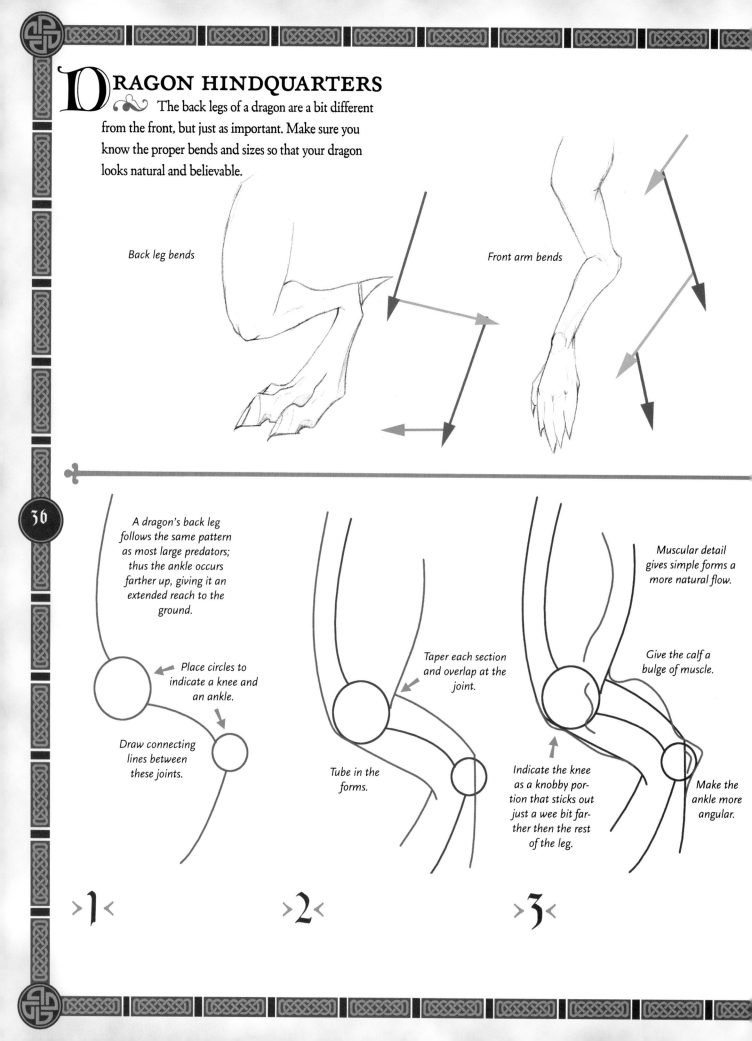

Back leg bends

Front arm bends

A dragon's back leg follows the same pattern as most large predators; thus the ankle occurs farther up, giving it an extended reach to the ground.

Place circles to indicate a knee and an ankle.

Draw connecting lines between these joints.

Taper each section and overlap at the joint.

Tube in the forms.

Muscular detail gives simple forms a more natural flow.

Give the calf a bulge of muscle.

Indicate the knee as a knobby portion that sticks out just a wee bit farther then the rest of the leg.

Make the ankle more angular.

>1<

>2<

>3<

Legs Help Define Your Dragon

The kind of legs you give your dragon determines more than just how he looks. It will also determine his abilities. Raptor-type (think eagle) legs will provide your dragon with sharp talons good for swooping and snatching. Canine- or feline-type legs will make your dragon a superior sprinter.

Tighten up your line work to complete the drawing, then erase any construction lines.

Any time a muscle bulges or a bone sticks out, shadows and highlights are created.

>4<

Keep your shadows falling in the same direction to reflect a solid light source and you'll have a very solid leg for your dragon to stand on!

>5<

LION-LIKE PAWS

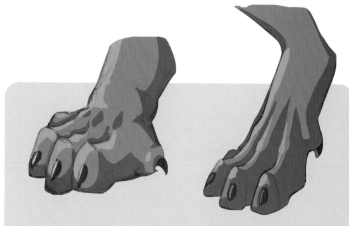

Lion-style paws are great for shorter and stockier dragons with lots of weight to throw around. Make sure to give a dragon with these paws big, hulking muscles to match.

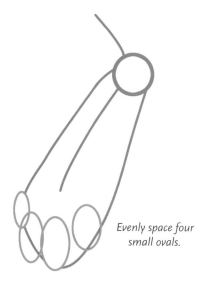

KITTY PAWS HAVE PADS

Remember, lion paws are padded, just like a cat's. If your creature is running or walking, you'll have to remember to add them.

PLANTIGRADE VS. DIGIGRADE

A *plantigrade* foot has the sole of the foot resting against the ground. These feet are firmly planted against the earth. A *digigrade* foot walks on its toes. Only the toes are planted on the ground, bearing the weight. The rest of the foot remains in the air.

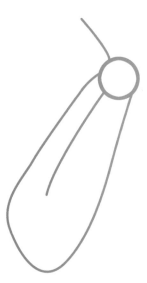

Place a large oval shape. We're doing digigrade paws so the creature's ankle should be high up in the air. The weight is on the toes.

> 1 <

Evenly space four small ovals.

The ovals wrap around the shape, so the two in the middle are farther front than the two behind.

> 2 <

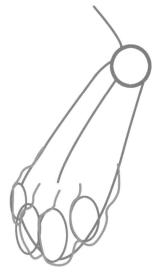

Trace around each oval, making each a toe.

> 3 <

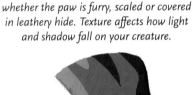

THE INK SCOOP

Inking your drawing makes line cleanup easy. Just draw all your construction lines in pencil, then do your finals in ink. When you're finished, go back in with an eraser and rub it over the entire drawing, leaving only the final ink lines behind.

A ballpoint pen will give you a finer, more varied ink line than markers, but watch for smudging! Some ballpoint pens leave unequal amounts of ink in a line causing much grief later on. Markers are not always the best solution either because they are very susceptible to bleeding. Many art stores carry disposable technical pens that are ideal for starting out with inks. They are fairly cheap, come in different colors and are easy to use.

Add some flesh to the rest of the leg.

Clean up any construction lines with a soft eraser.

Before you begin shading or coloring, decide whether the paw is furry, scaled or covered in leathery hide. Texture affects how light and shadow fall on your creature.

Don't drag the claws too far beyond the end of the foot—your creature needs to be able to place the foot down on the ground.

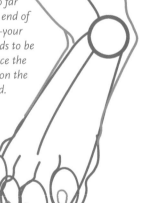

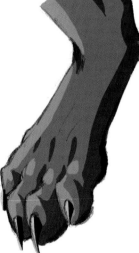

Put some nice sharp claws in each of those toes.

Put down some final line work over the frame. Give the bottom of each toe a rounded shape to indicate the paw pad.

This paw's leathery hide is smooth, giving it sharp highlights.

 >4<

>5<

>6<

TALON-LIKE CLAWS

Taloned claws are perfect for snatching things off the ground and carrying them up high into the air. They're a bit large and unwieldy in just about every other instance, but darn, do they look impressive!

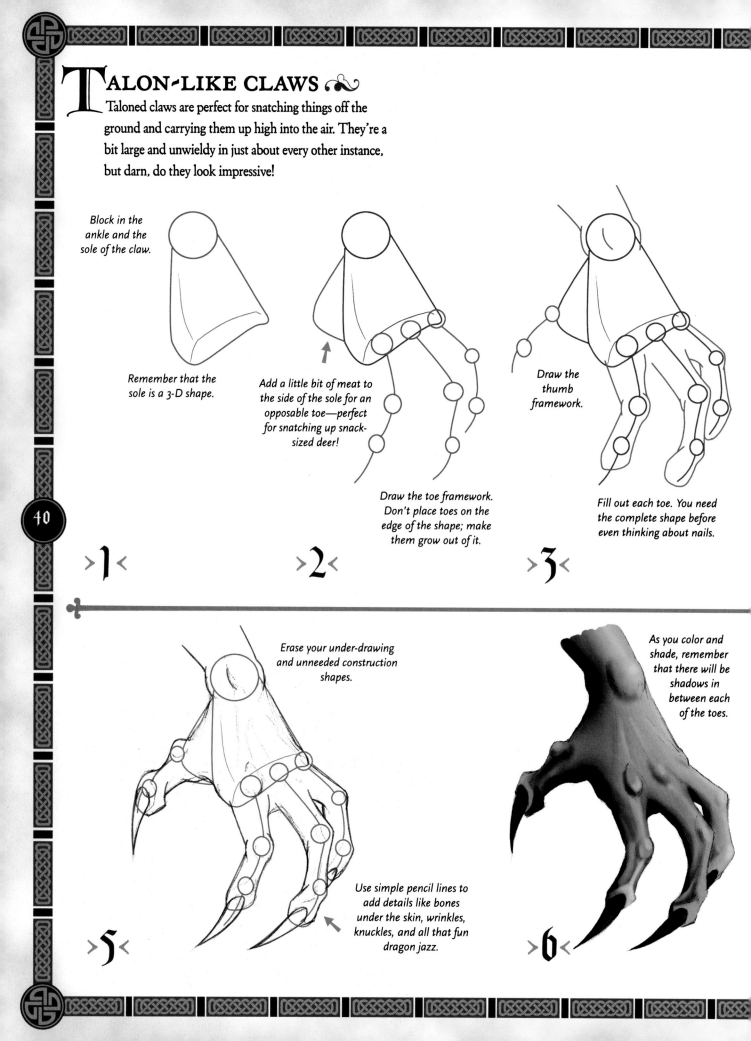

Block in the ankle and the sole of the claw.

Remember that the sole is a 3-D shape.

>1<

Add a little bit of meat to the side of the sole for an opposable toe—perfect for snatching up snack-sized deer!

Draw the toe framework. Don't place toes on the edge of the shape; make them grow out of it.

>2<

Draw the thumb framework.

Fill out each toe. You need the complete shape before even thinking about nails.

>3<

Erase your under-drawing and unneeded construction shapes.

Use simple pencil lines to add details like bones under the skin, wrinkles, knuckles, and all that fun dragon jazz.

>5<

As you color and shade, remember that there will be shadows in between each of the toes.

>6<

For retractable talons, add a tiny ridge of skin between the nail and the flesh.

SET THE NAILS INTO THE FINGER FLESH

When endowing your dragon with claws and talons, always remember to set the claw back into the digit. Doing this will make your dragon's hands natural and awesome. Not, perhaps, as awesome as mine, but awesome nonetheless.

Add the nails once the toe shapes are well-formed. Set the nails back into each of the toes.

>4<

OPEN VS. CLOSED TALON

Decide early on whether you want your dragon's scary talons open or closed.

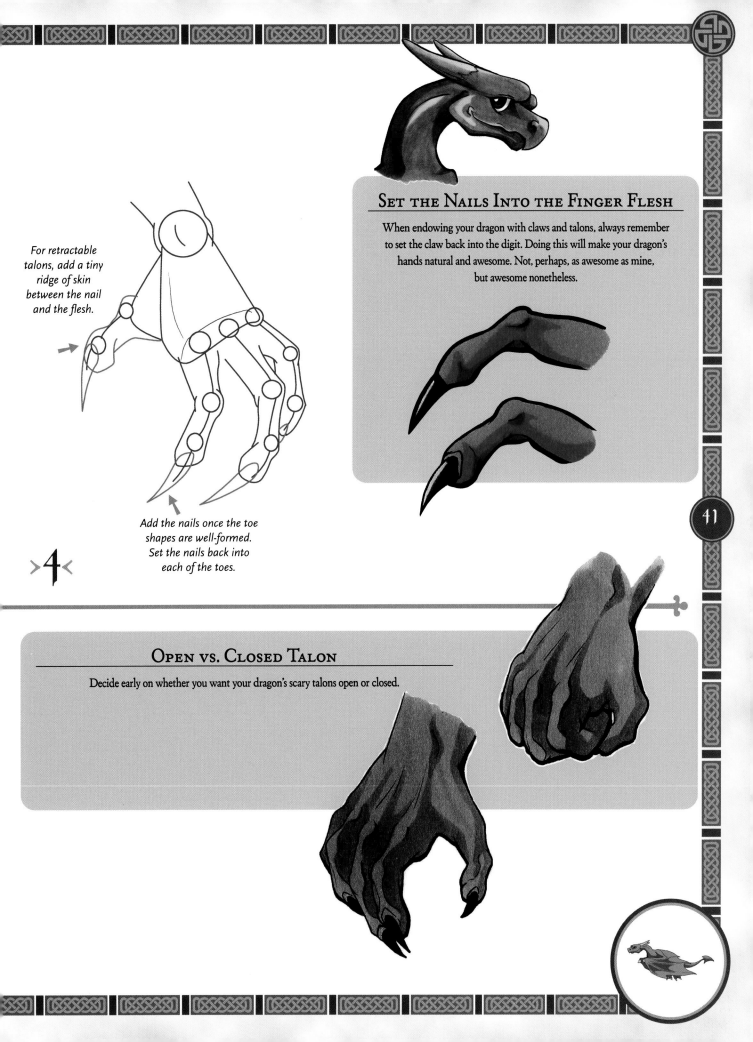

LION-LIZARD HIND PAWS

The back paws of a dragon bear a lot of weight, especially if you want your dragon to sometimes stand on two legs to get a better angle for shooting flames at those pesky knights. The long, scaly toes of the lizard combined with the retractable claws and digigrade example feline foot gives your dragon superior footing, while also giving him extra limbs with which to snatch up victims.

Rough in a large shape for the mass of the foot and circles to indicate how many toes you want.

>1<

COMBINE FOOT-TYPES

Don't limit yourself when it comes to types of feet. You can combine nearly any foot-type with any other to come up with unique dragons. The trick is to take the most positive aspect of both types and eliminate the weaknesses. If you enjoy the large standing base that a hoof provides, but also want the scariness of claws, create a hoof-claw for a large foot that can still do damage.

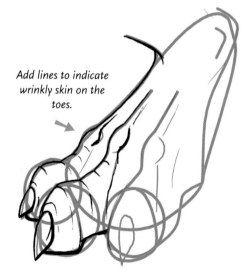

Add lines to indicate wrinkly skin on the toes.

Make your line work crisp and erase your construction lines.

>4<

Make each individual toe connect farther into the foot, giving it a powerful, believable feel.

Draw in the back of the paw.

The second half of the paw goes vertically to connect up to the rest of the leg.

Insert claws into each of the toes.

Draw the bottom half of the paw with a diagonal because the paw is set at a 3/4 view. The diagonal gives it the illusion of going back into space.

>2<

>3<

A heavier line indicates shadows in the back of the foot and behind things like ankles.

Short, crisp lines indicate wrinkly skin on the toes.

Shade the space between each toe. Adding that shadow really gives the paw 3-D weight.

>5<

>6<

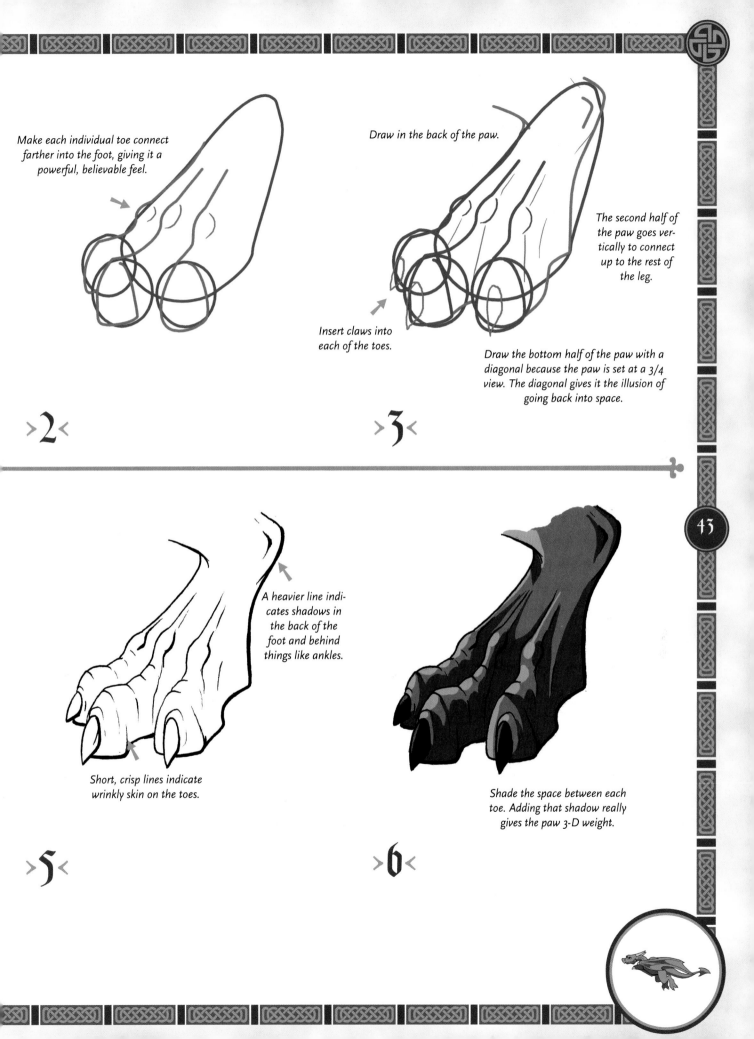

DRAGON BODIES:
BASIC SHAPES AND ANATOMY

Okay, so we're going to discuss the anatomy of a creature that exists nowhere but in our minds. Sounds kind of silly to say that something made from pure imagination does not look correct, but that will happen if your creature doesn't look believable. To help make your dragon as real as possible, base its structure on real creatures.

The ideal dragon is likely a mix of cat, bird and reptile body types. The trick is choosing which parts to keep and which ones to throw out. You want it to feel like a single creature.

BIRD ANATOMY
First, I've based my dragon off a bird. Surely it can fly! It's genius!

Though this creature looks flight-worthy, it's lost its front legs and it's missing that classic long neck, rows of teeth and feline grace that most people feel dragons should have. I guess we'll just have to look at something else to base our creature off of.

CAT ANATOMY
So, let's try a dragon with mostly feline anatomy. This dragon walks on all fours, stalking silently through the plains. It looks well-proportioned and anatomically possible, but not very much like the myth we have in our heads. The wings are far too small to fly and the short cat-neck is not nearly serpentine enough.

LIZARD ANATOMY

Dragons are large lizards, right? Like dinosaurs? Okay, here's my totally awesome, four-legged, big-winged dragon lizard! Feel his majesty…or not. No, this creature is a bit too squat for what I'm looking for.

COMBINE THEM ALL

Geez…if we can't make the anatomy up, and we can't base it off reality, what can we do?! The answer: Throw it in a blender at the highest setting for an hour, or as long as it takes to mix up your dragon.

DRAGON SKELETON

Though dragons are creatures of fantasy, you want to draw them as if they were real. You want to make people believe! When drawing, think about the dragon like you would a real animal. Think about the bones, the joints and the muscles underneath the skin.

Remembering the bone structure is especially important when drawing the head, wings and body. You do not want your dragon's body to be a flat tube—you want to show hints of a rib cage and the way the belly sucks in as it moves to the pelvis. Your dragon needs sockets for its eyes to set in instead of having them pasted flatly on the outside of the head.

Remember the muscles of your dragon, too! Powerful wing muscles will be needed to propel your dragon into the air. Legs should not be sticks, but muscle curved over bone showing mighty power!

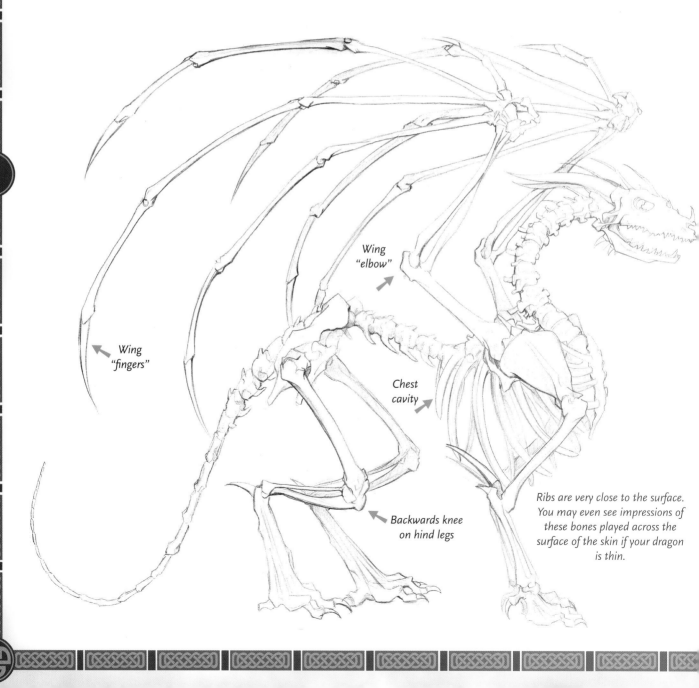

Wing "elbow"

Wing "fingers"

Chest cavity

Backwards knee on hind legs

Ribs are very close to the surface. You may even see impressions of these bones played across the surface of the skin if your dragon is thin.

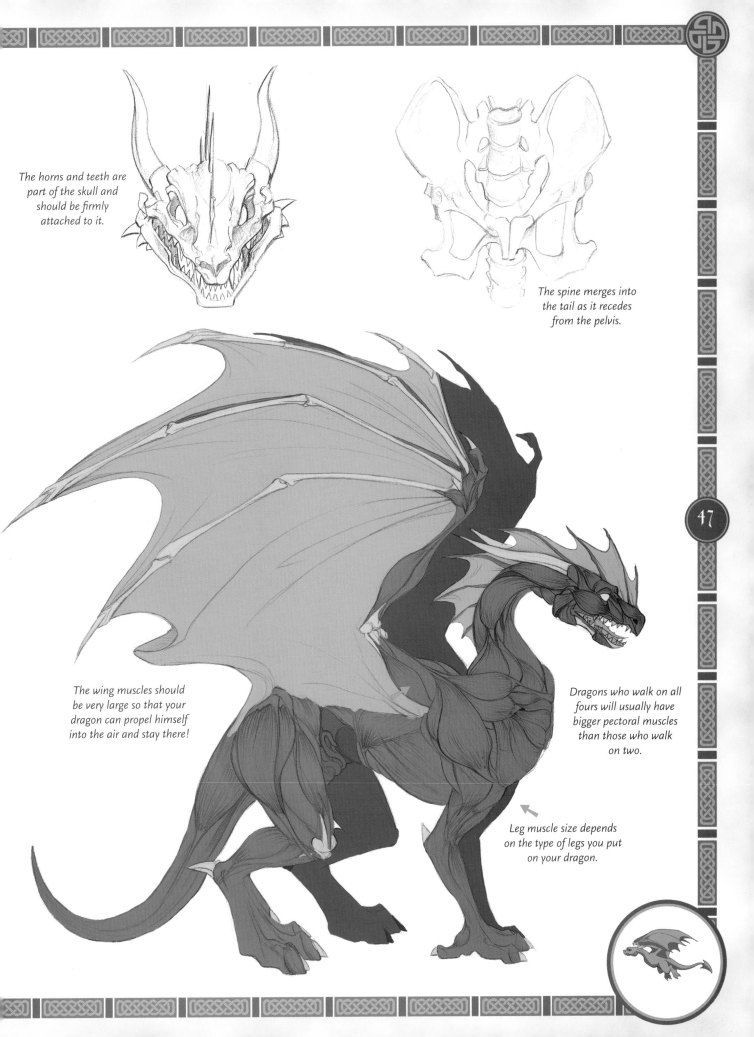

The horns and teeth are part of the skull and should be firmly attached to it.

The spine merges into the tail as it recedes from the pelvis.

The wing muscles should be very large so that your dragon can propel himself into the air and stay there!

Dragons who walk on all fours will usually have bigger pectoral muscles than those who walk on two.

Leg muscle size depends on the type of legs you put on your dragon.

DRAGON BODY, SIDE VIEW

~ Now that you know a bit more about dragon anatomy, let's try that side view from pages 16–19 again. A side view of your dragon's body is a very direct approach that may help simplify things because the overlap is minimal. For now, we'll focus on the body itself, not the limbs, wings or face.

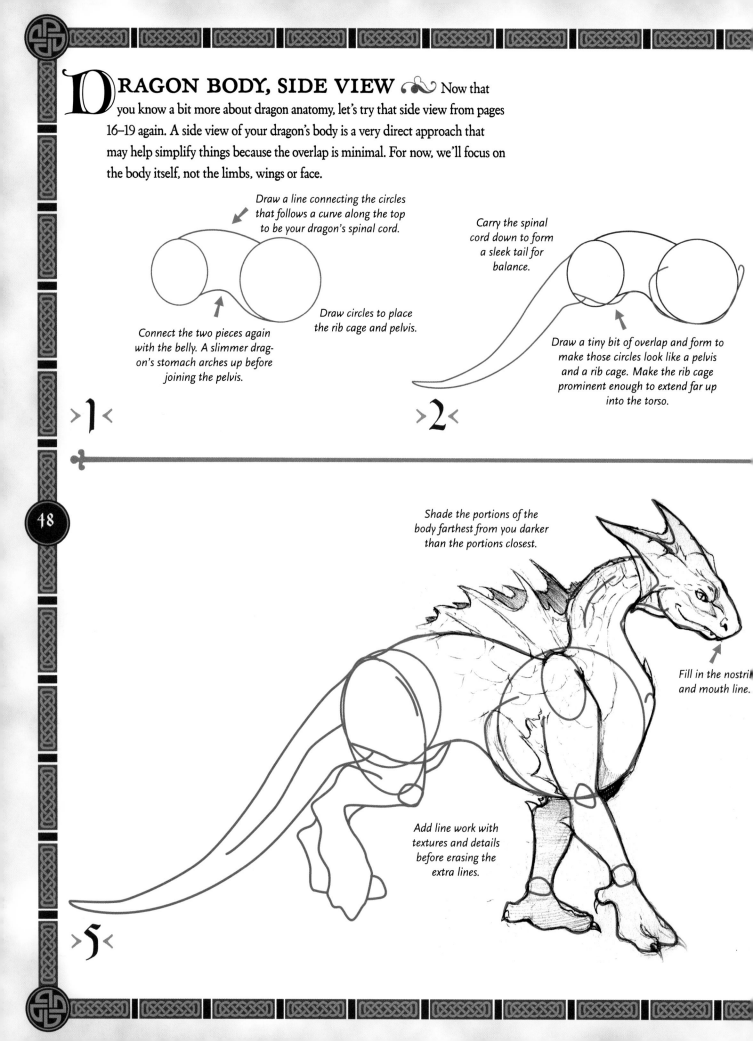

Draw a line connecting the circles that follows a curve along the top to be your dragon's spinal cord.

Connect the two pieces again with the belly. A slimmer drag-on's stomach arches up before joining the pelvis.

Draw circles to place the rib cage and pelvis.

>1<

Carry the spinal cord down to form a sleek tail for balance.

Draw a tiny bit of overlap and form to make those circles look like a pelvis and a rib cage. Make the rib cage prominent enough to extend far up into the torso.

>2<

Shade the portions of the body farthest from you darker than the portions closest.

Fill in the nostril and mouth line.

Add line work with textures and details before erasing the extra lines.

>5<

The neck is slimmer where it meets the head and wider where it trails into the body.

e the neck and tail a
or two to make them
eem well-muscled.

Now that you have a great body to build off of, add the head and limbs!

>3<

>4<

Follow your line work and vary the tones as you color your dragon and let it loose to rampage and destroy!!

>6<

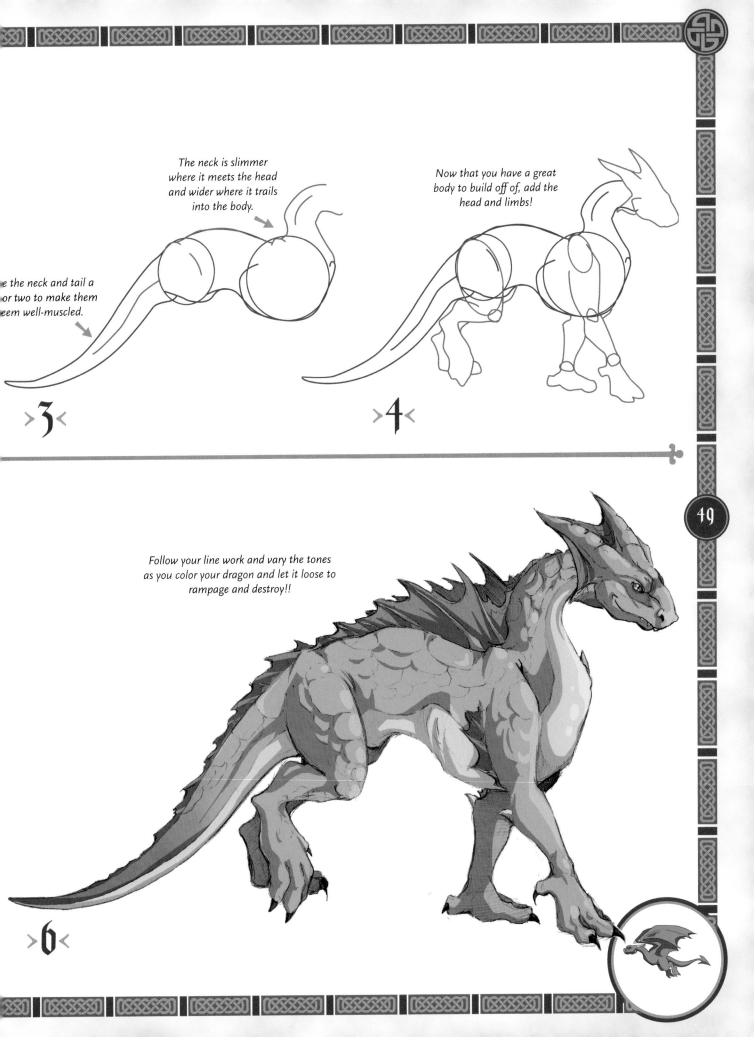

DRAGON WINGS AND FLIGHT

If dragons were bound by the laws of science, they'd likely be flightless the way that most people envision them. There are several problems in making their flight believable, not the least of which is the fact that all vertebrates on earth, except the snake, have four limbs. Adding wings on the back of a dragon creates a fifth and sixth limb that is difficult to envision properly. Really consider the placement of the wings if you're going to be doing any illustrations involving massive wings or flight.



CONNECTION POINTS
You need some sort of anchor for your wing so that it is not floating magically along, attaching itself to various places depending on the pose. So in almost all cases the wing will connect in its own socket behind the shoulder blade.

50

FLIGHT TO SCALE (AHHH!)

Dragons are *huge*, so making their flight believable is quite a challenge. Generally, the bigger your wings are, the more believable they are as flying mechanisms. That's provided they are heavily muscled as well as long. The problem with this is that it can become very awkward to fit the creature onto your page with those giant wings getting in your way!

COMMON SIZE (KINDA BELIEVABLE)

Taking the wings down to a size that's about equal to the size of the dragon's body makes fitting the creature on your page much easier. Though something large getting off the ground with wings that size might not be intellectually believable, visually it can be very appealing, and that's what art is all about—creating spiffy pictures!

IMPOSSIBLE SIZE (BUT CUTE!)

Another option is to make your wings very tiny, rendering the dragon flightless, but allowing you a lot more room to work with the dragon's head, claws, body and tail. Emphasize whichever parts you feel best represent the personality of your dragon.

OPEN WINGS

Wings are an important part of many drag-ons. They act as both decoration and massive sails that give your dragon power over the air! A wing functions much like an arm. Bat wings, the most commonly used base for dragon wings, are actually arms and paws with extremely long fin-gers and skin that grows between them. Most dragons have bat-like wings that stretch, fold and curl. Begin with the most basic elements of the wing and use them as a reference point for everything that follows.

Draw ovals for the shoulder, elbow and wrist.

Do not be afraid to use arched lines, as bones often bend.

Connect these areas with lines.

>1<

THE WINGS MUST MEET THE BODY

Always remember to drag the skin of your wing down to meet with the back farther down your dragon's body. A dragon cannot fly if there is nothing there to catch the breeze!

Flesh out the fingers.

Draw indications of the knuckles.

>4<

Wings have fingers too. Add the short digit for the thumb and branch out four long ones to make up the area where the largest mass of skin stretches.

>2<

Make the the arm portions thickest at the bases and gradually taper them down. A thick base gives the wings the power to actually flap.

Add another branch from the elbow to shorten the gap between the figure and where the membrane meets the body.

>3<

For a more wrinkled look, add overlap lines at the base of the wing and near the base of the hand.

Make U-shapes between each finger for the skin.

>5<

Erase extra construction lines and tighten up your line work before adding color.

Congratulations on drawing your spiffy dragon wing!

>6<

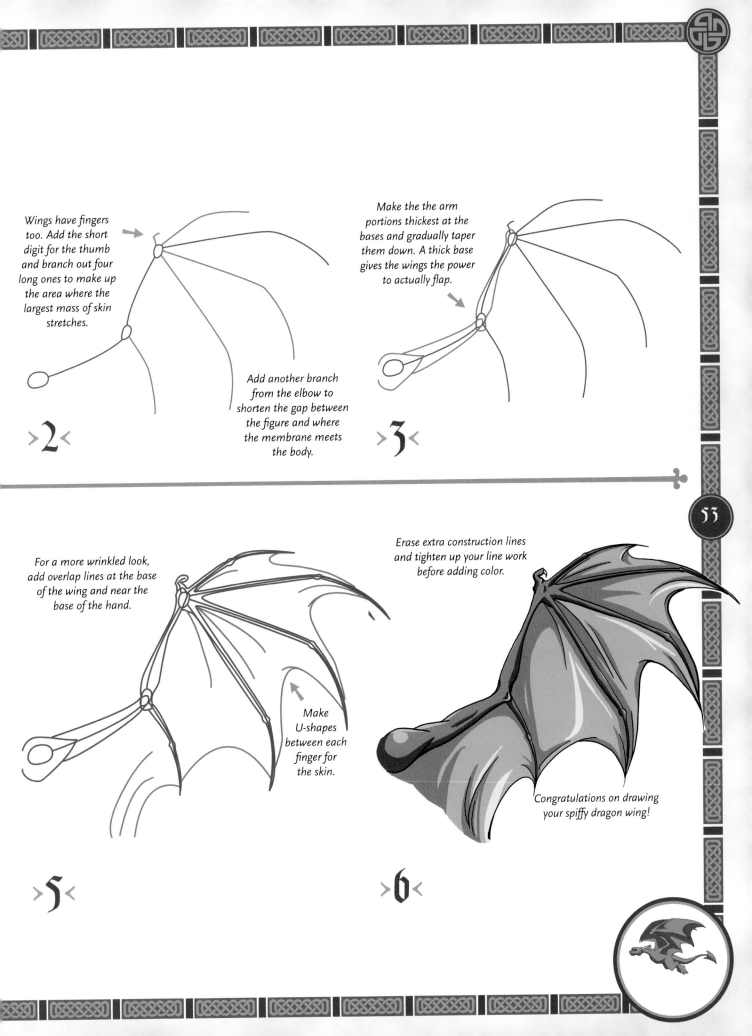

CURVED OR OVERLAPPED WINGS

Curved wings change drastically depending upon the angle. This type of pose is common during flight or during the unfurling and refolding of the wings. A curved wing also takes up less space since it overlaps itself, so your page is not full of wing...it's full of dragon!

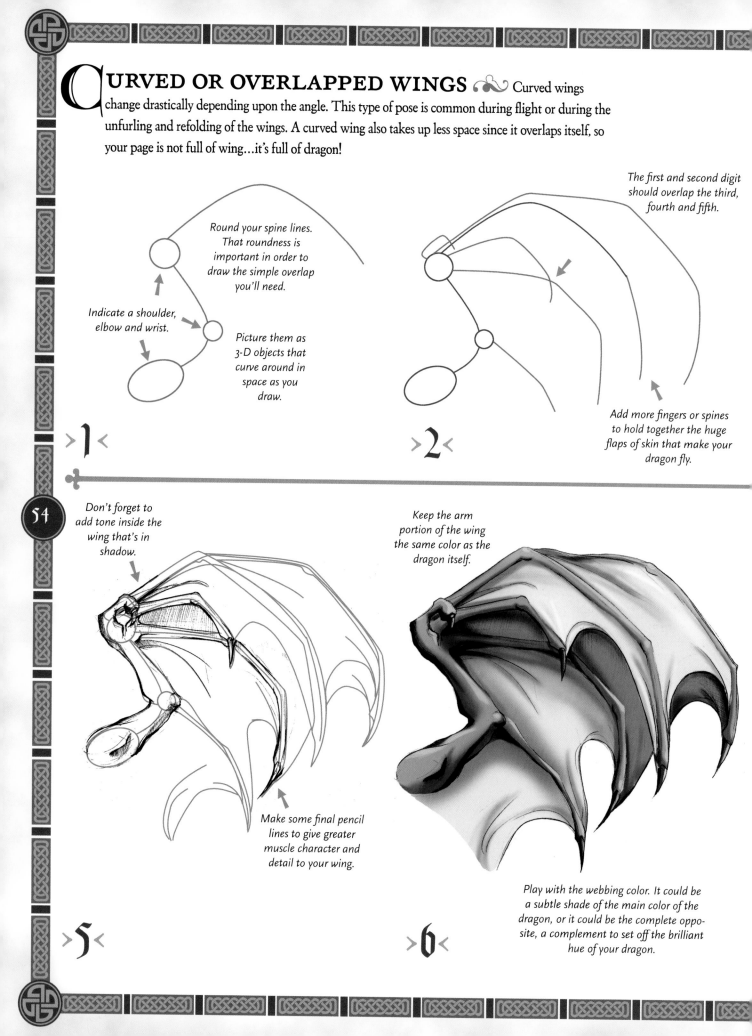

Round your spine lines. That roundness is important in order to draw the simple overlap you'll need.

Indicate a shoulder, elbow and wrist.

Picture them as 3-D objects that curve around in space as you draw.

>1<

The first and second digit should overlap the third, fourth and fifth.

Add more fingers or spines to hold together the huge flaps of skin that make your dragon fly.

>2<

Don't forget to add tone inside the wing that's in shadow.

Make some final pencil lines to give greater muscle character and detail to your wing.

>5<

Keep the arm portion of the wing the same color as the dragon itself.

Play with the webbing color. It could be a subtle shade of the main color of the dragon, or it could be the complete opposite, a complement to set off the brilliant hue of your dragon.

>6<

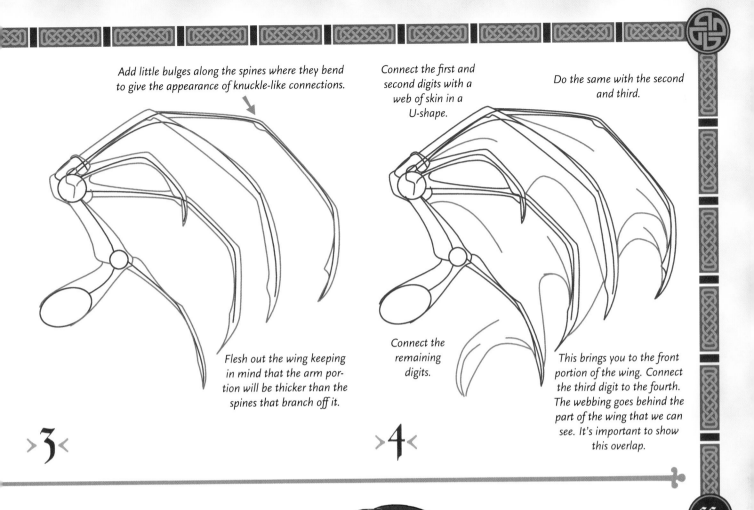

Add little bulges along the spines where they bend to give the appearance of knuckle-like connections.

Flesh out the wing keeping in mind that the arm portion will be thicker than the spines that branch off it.

Connect the first and second digits with a web of skin in a U-shape.

Connect the remaining digits.

Do the same with the second and third.

This brings you to the front portion of the wing. Connect the third digit to the fourth. The webbing goes behind the part of the wing that we can see. It's important to show this overlap.

>3<

>4<

55

COLOR BASICS

You can take several different approaches to color as you plan out your dragon. If you don't carefully consider the look you're going for though, you could end up with a dragon that looks like a clown of dragonkind. Orange with pink and green polka dots may not be a great choice.

Analogous colors, or colors that are close together on the color wheel, are always a safe way to go. A dragon made up of blue, blue-green and green or a dragon made of red, red-orange and orange seems fairly modest and not outright gaudy. If you're looking for an accent color, running to the opposite side of the color wheel for the complementary color will generally provide a pleasing solution. Green complements red, orange complements blue, and purple complements yellow.

FOLDED WINGS ✤ Wings are large

body parts and if you want your dragon to be diving, walking or sleeping, you'll want those wings folded back and out of the way. Folded wings look extremely complicated to pull off at first. However, you'll soon find out that's just not true. A folded wing is exactly the same as an open wing. Just because it's changed position doesn't mean that it's changed anatomy.

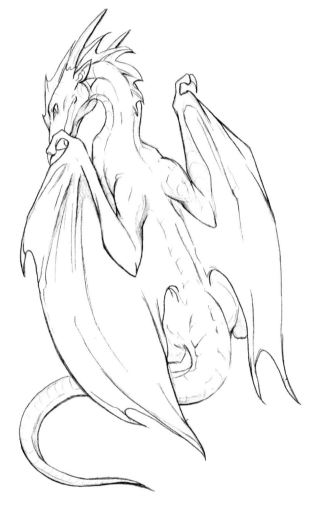

Draw the shoulder, elbow and wrist.

They're much closer together because the wing isn't fully extended.

>1<

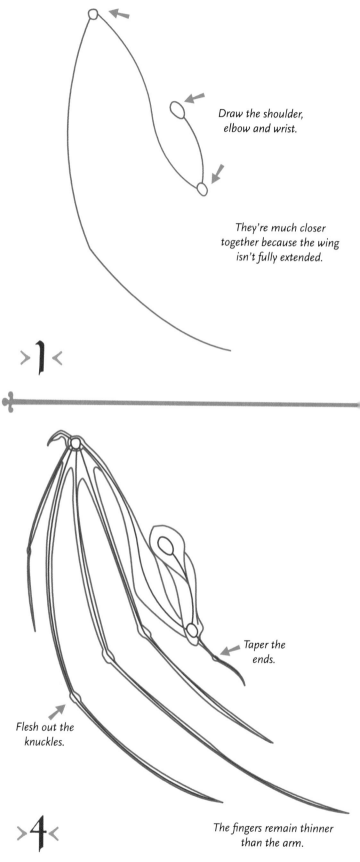

Taper the ends.

Flesh out the knuckles.

>4<

The fingers remain thinner than the arm.

DRAGON WITH FOLDED WINGS

A folded wing attaches to the dragon exactly the same as an open wing would. The wing's connection doesn't move, but the position of the outer part of it does. A wing that's folded and tucked will be much more compact than one that is splayed open.

The fingers fall closer together, but they retain the same proportions as before. Don't let the pose intimidate you.

>2<

Add lines to more solidly indicate the bones.

In a very close folded position, the forearm sometimes overlaps the back, obscuring it completely. This tuck isn't so severe.

>3<

This step is sometimes tricky. The wing is folded, so the membrane must hang loose.

The largest area of flap is between the body and the fingers. This should overlap, bunch and drape like fabric.

Use lazier U-shapes to connect the fingers.

>5<

Define your wrinkles well and the wing will become more life-like than ever.

Each wrinkle should have a main highlight where the light hits and dark shadows in the creases.

>6<

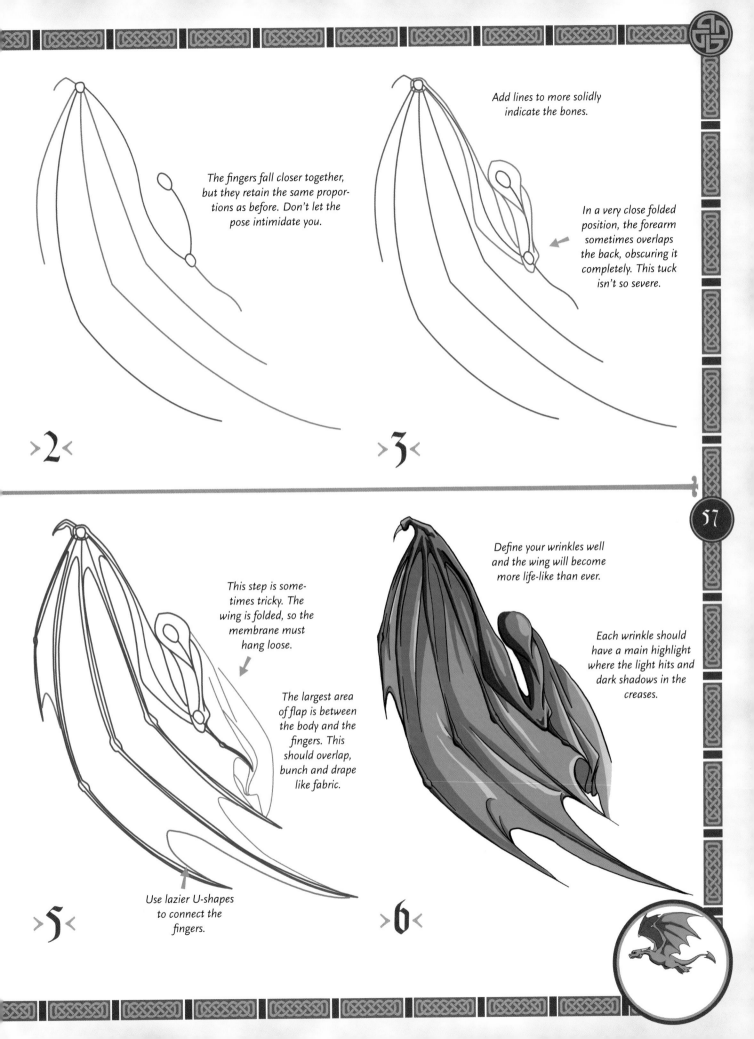

DRAGON BODY, FRONT VIEW

Now that you've mastered dragon wings (you have, haven't you?!), let's put those wings on a wyrm in a front view. A head-on view of your dragon is a great way to get to know him or her. Paying attention to symmetry is a must because from the front view, any imbalance will be obvious to the viewer. Don't let your drawing sag on the right if it's not sagging on the left. Strive for balance.

Place circles for the rib cage and pelvis.

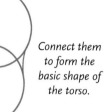

Connect them to form the basic shape of the torso.

>1<

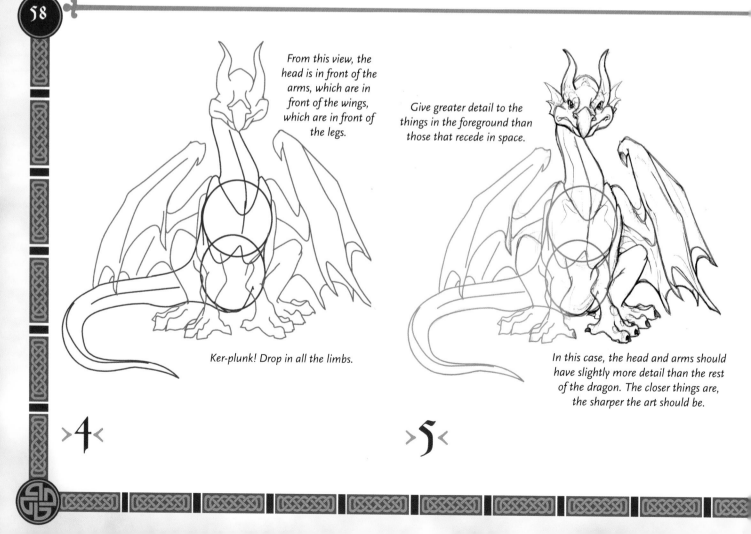

From this view, the head is in front of the arms, which are in front of the wings, which are in front of the legs.

Ker-plunk! Drop in all the limbs.

Give greater detail to the things in the foreground than those that recede in space.

In this case, the head and arms should have slightly more detail than the rest of the dragon. The closer things are, the sharper the art should be.

>4<

>5<

2

Pull out a designated shape for the rib cage and pelvis.

The rib cage is closer to you than the rest of the dragon so puff it out accordingly.

Pull out the tail.

3

The neck and body should be a continuous, flowing shape.

Set the neck and shoulders into the torso.

The neck grows into the front of the dragon instead of just being plunked down on top of it.

6

Midnight blue is perfect for sneaking up on unsuspecting knights.

The only white on this guy is the highlight in his eye.

Use lighter shades of the same color to indicate highlights.

Neon will pay for this.

COLOR WITH CARE

Color has a lot to do with a dragon's personality and place in the world. Consider this before diving in headfirst with the first crayon you pull from the box. Red will give you a creature of flame and violence, black leans towards dark caves and the undead, while a white dragon lends itself more to ice and magic. Blue brings to mind storms, and gold brings treasure and wisdom. Green is, of course, the best color choice. Green dragons are the most cunning, intelligent, majestic, glorious and fearsome of dragonkind. I suppose the other colors are OK too, but based upon past experience, I've never met a dragon more awesome than I. Thus, logic dictates that green equals *The Über-Dragon.*

DRAGON BODY, BACK VIEW

The back view of the dragon is useful when doing illustrations that look out over a vast expanse of landscape or an intricate battle or gathering. Typically, this view is not used for showing off "look how cool my dragon is," but is a part of a larger scene.

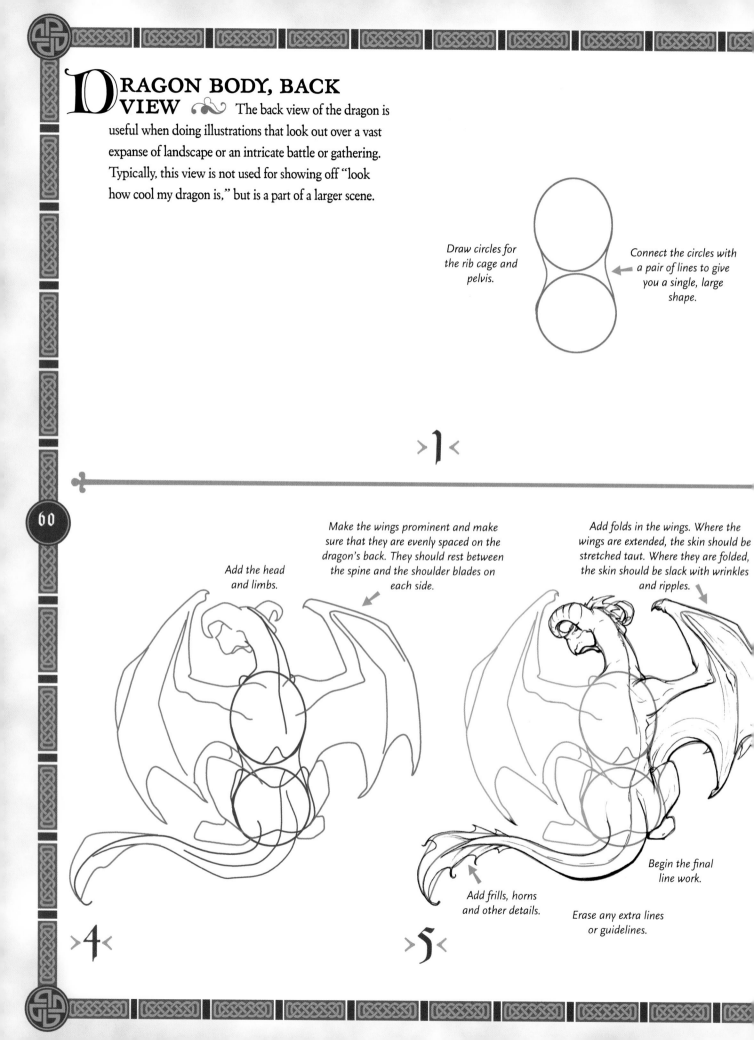

Draw circles for the rib cage and pelvis.

Connect the circles with a pair of lines to give you a single, large shape.

> 1 <

Add the head and limbs.

Make the wings prominent and make sure that they are evenly spaced on the dragon's back. They should rest between the spine and the shoulder blades on each side.

Add folds in the wings. Where the wings are extended, the skin should be stretched taut. Where they are folded, the skin should be slack with wrinkles and ripples.

Add frills, horns and other details.

Begin the final line work.

Erase any extra lines or guidelines.

> 4 <

> 5 <

You aren't going to see much detail in the chest because it is facing away from you.

Branch the lower section into a full-fledged pelvis with tail.

> 2 <

The neck and spine should be one solid, continuous line.

Attach a neck and shoulders to the body.

> 3 <

Once your drawing is done, it is time for color! Lighter colored highlights show off shiny, reflective skin.

> 6 <

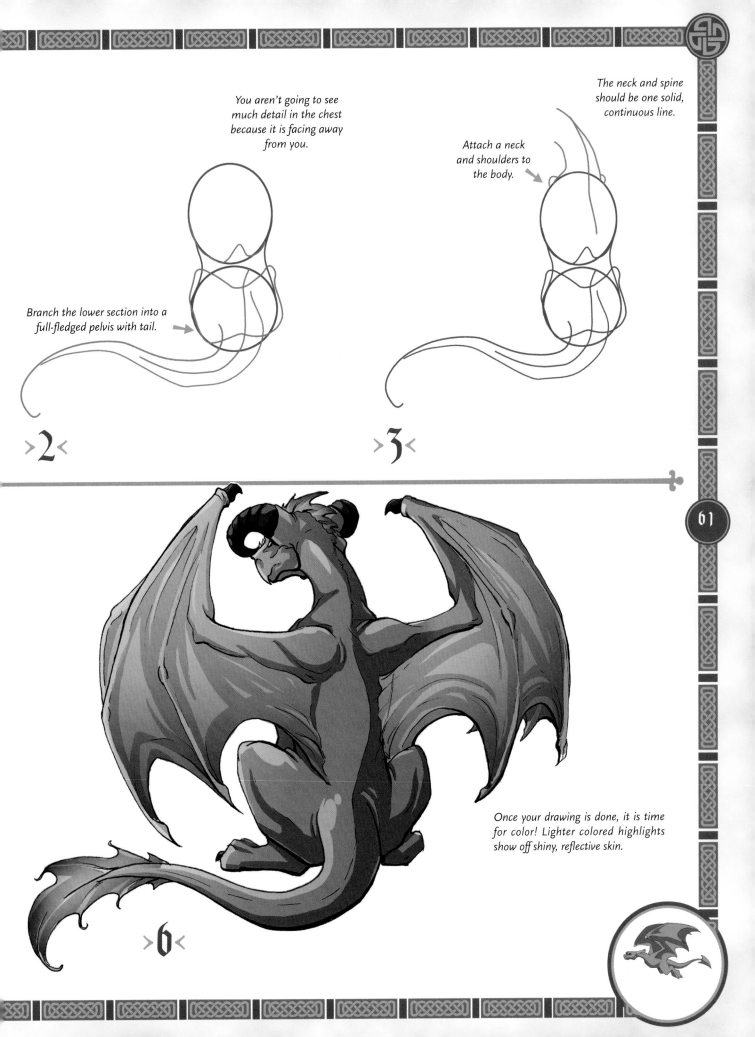

WESTERN DRAGON

It's time to take all you've learned about dragon anatomy and put it together into a complete creature. Western dragons have wings, scales and horns. They are typically four-limbed, animal-like creatures that breathe fire, kidnap damsels, and toast the knights that prance up to rescue said damsels. In general, they are more monster-like than their Eastern cousins.

Most are not benevolent creatures and are certainly nothing a mere human would want to tangle with!

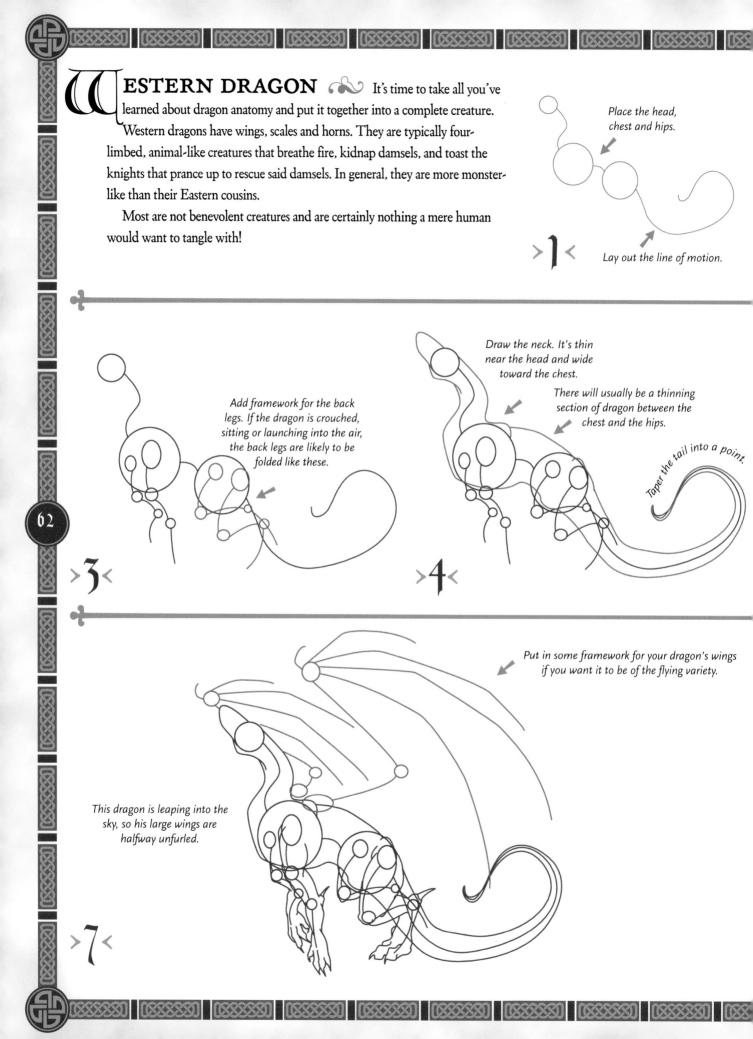

Place the head, chest and hips.

Lay out the line of motion.

> 1 <

Add framework for the back legs. If the dragon is crouched, sitting or launching into the air, the back legs are likely to be folded like these.

> 3 <

Draw the neck. It's thin near the head and wide toward the chest.

There will usually be a thinning section of dragon between the chest and the hips.

Taper the tail into a point.

> 4 <

Put in some framework for your dragon's wings if you want it to be of the flying variety.

This dragon is leaping into the sky, so his large wings are halfway unfurled.

> 7 <

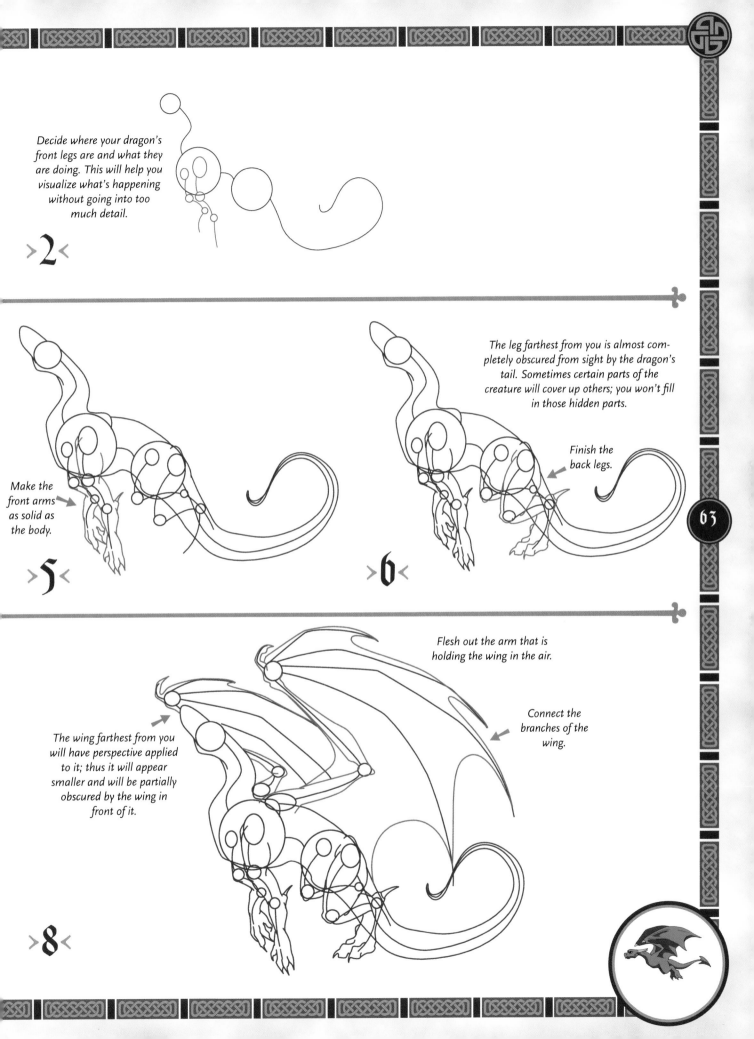

Decide where your dragon's front legs are and what they are doing. This will help you visualize what's happening without going into too much detail.

>2<

Make the front arms as solid as the body.

>5<

The leg farthest from you is almost completely obscured from sight by the dragon's tail. Sometimes certain parts of the creature will cover up others; you won't fill in those hidden parts.

Finish the back legs.

>6<

Flesh out the arm that is holding the wing in the air.

Connect the branches of the wing.

The wing farthest from you will have perspective applied to it; thus it will appear smaller and will be partially obscured by the wing in front of it.

>8<

Decide whether you want your creature to have an open mouth, puffed cheeks or a closed maw. This dragon is calling out as it lifts into the air. Since the head is facing upward, we can see a little into the mouth itself.

Add horns, scales, spines, frills, webbing, spikes and plates!

Add plates along the back of the neck if you want to make him look even more indestructible.

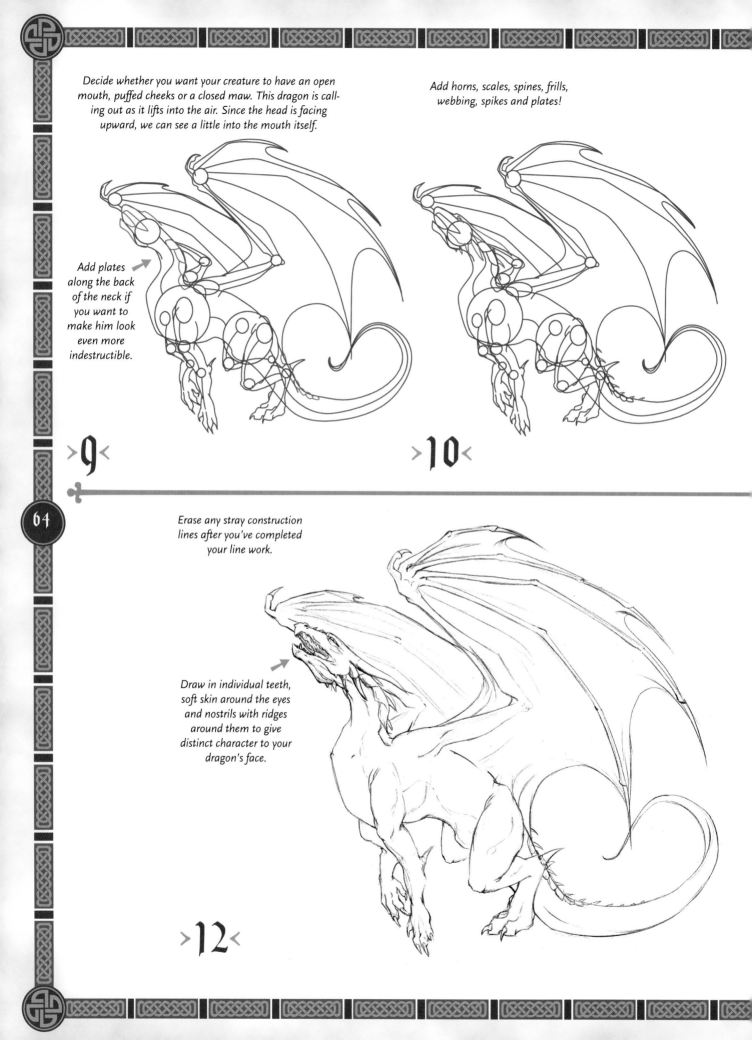

>9<

>10<

Erase any stray construction lines after you've completed your line work.

Draw in individual teeth, soft skin around the eyes and nostrils with ridges around them to give distinct character to your dragon's face.

>12<

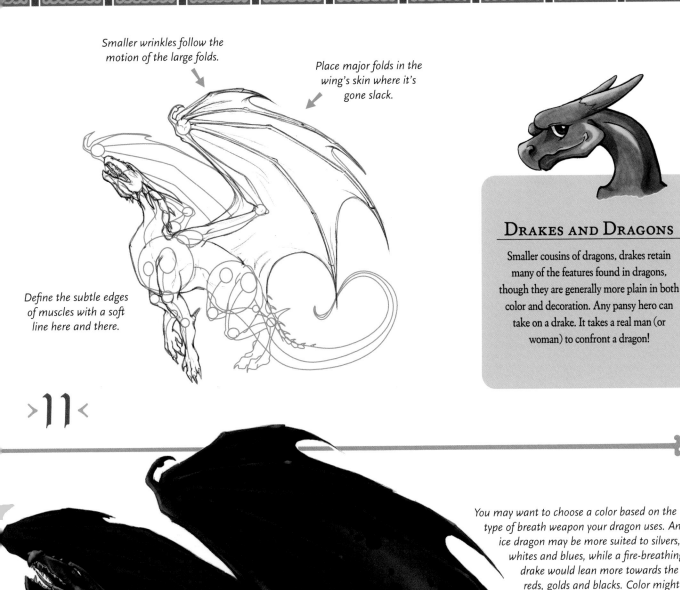

Smaller wrinkles follow the motion of the large folds.

Place major folds in the wing's skin where it's gone slack.

Define the subtle edges of muscles with a soft line here and there.

>11<

DRAKES AND DRAGONS

Smaller cousins of dragons, drakes retain many of the features found in dragons, though they are generally more plain in both color and decoration. Any pansy hero can take on a drake. It takes a real man (or woman) to confront a dragon!

You may want to choose a color based on the type of breath weapon your dragon uses. An ice dragon may be more suited to silvers, whites and blues, while a fire-breathing drake would lean more towards the reds, golds and blacks. Color might also reflect personality. A cheerful yellow, a melancholy slate, or a worn-out brown may change how the dragon behaves. Then again, the idea of an insanely evil pastel dragon is rather fun!

>13<

EASTERN DRAGON ⚜

Unlike their Western counterparts, Eastern dragons are often benevolent beings. According to Chinese mythology they come in five types.

+ CELESTIAL DRAGONS guard the gods and emperors.

+ SPIRIT DRAGONS control the wind and rain.

+ EARTH DRAGONS guard the rivers and seas .

+ TREASURE-HOARDERS guard...hordes of treasure...*hmmm.*

+ IMPERIAL DRAGONS are, well, imperial. This dragon has five claws instead of the standard four. And no one but the emperor was allowed to wear this type of dragon on penalty of death! (See, dragons *are* important!)

All types of Eastern dragons share some common characteristics, though: features mixed from many animals; long, serpentine bodies; manes; four to five claws on each hand; branched horns; and expressive faces. This demonstration shows a fantasy-oriented take on the creature, rather than the stylized, cultural icons used in traditional Eastern art.

The Eastern dragon requires a long line of motion that flows through the air.

Draw out the way that you would like your dragon to twist and turn.

Draw circular indicators for the head, torso and hips.

>1<

Closely follow your line of motion with two major lines to connect your dragon's head, neck, torso and hips .

>4<

Since this dragon is twisting in space, the front portion is closer to you than the back so the lines should overlap and run into the form.

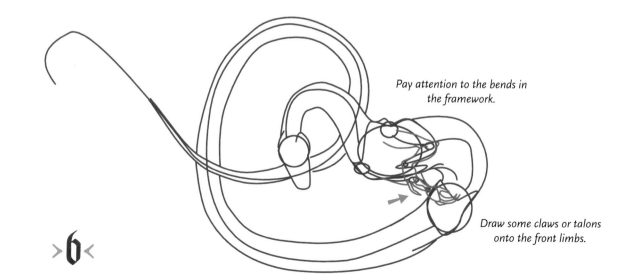

Pay attention to the bends in the framework.

>6<

Draw some claws or talons onto the front limbs.

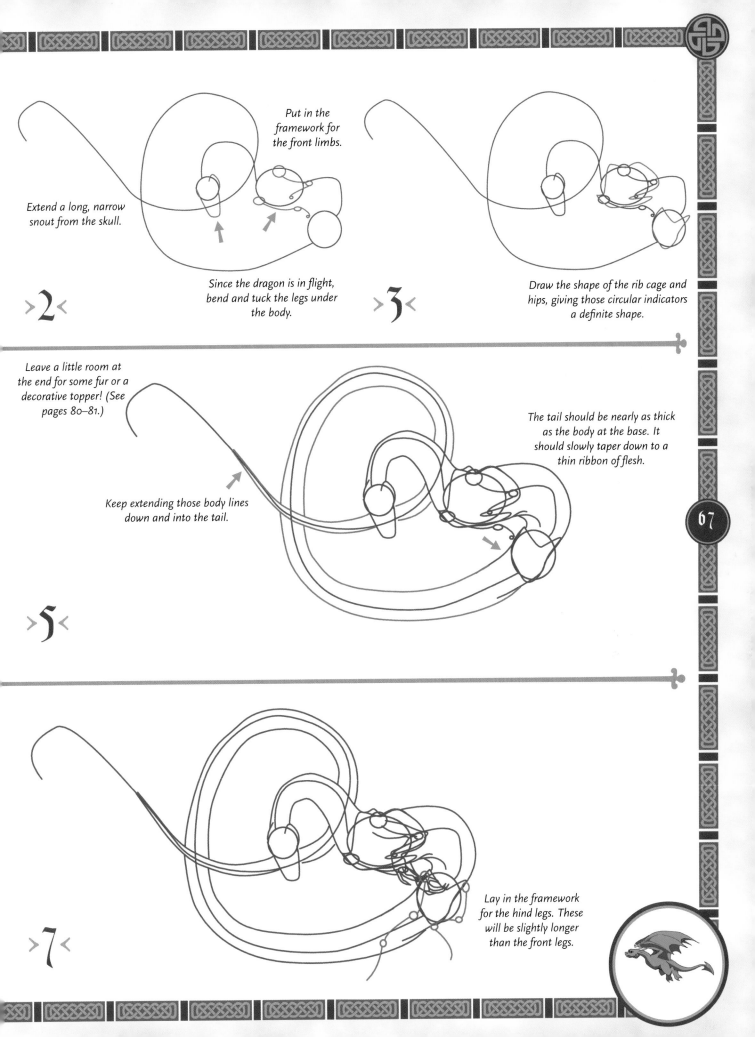

Put in the framework for the front limbs.

Extend a long, narrow snout from the skull.

Since the dragon is in flight, bend and tuck the legs under the body.

>2<

Draw the shape of the rib cage and hips, giving those circular indicators a definite shape.

>3<

Leave a little room at the end for some fur or a decorative topper! (See pages 80–81.)

Keep extending those body lines down and into the tail.

The tail should be nearly as thick as the body at the base. It should slowly taper down to a thin ribbon of flesh.

>5<

Lay in the framework for the hind legs. These will be slightly longer than the front legs.

>7<

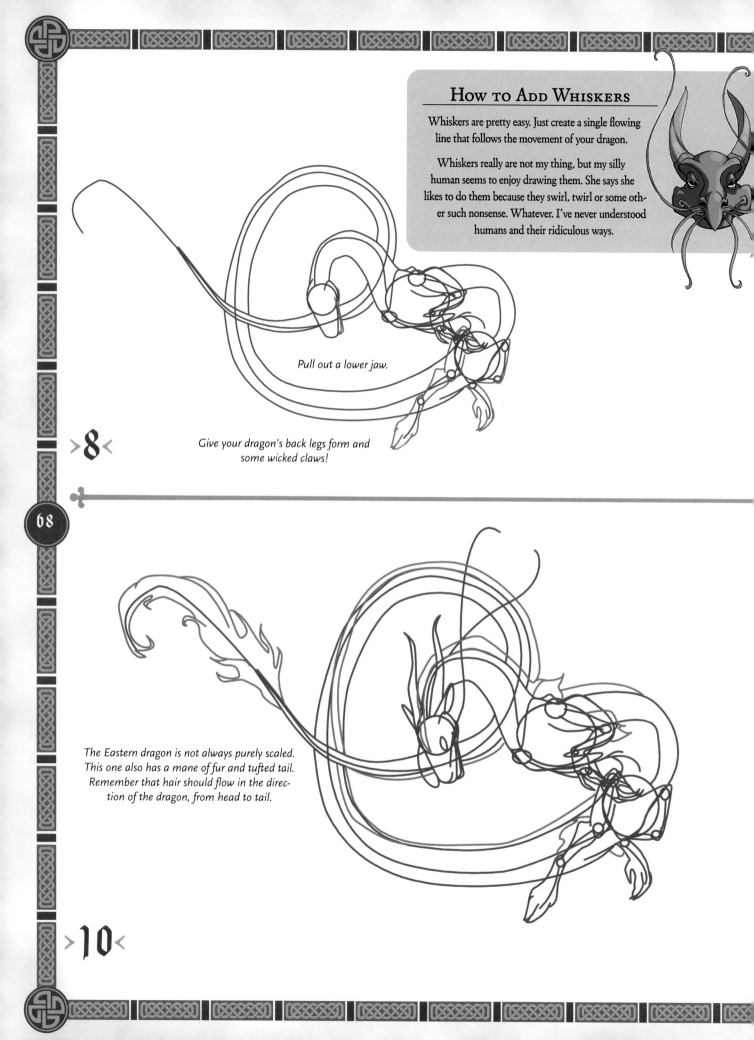

HOW TO ADD WHISKERS

Whiskers are pretty easy. Just create a single flowing line that follows the movement of your dragon.

Whiskers really are not my thing, but my silly human seems to enjoy drawing them. She says she likes to do them because they swirl, twirl or some other such nonsense. Whatever. I've never understood humans and their ridiculous ways.

Pull out a lower jaw.

>8<

Give your dragon's back legs form and some wicked claws!

The Eastern dragon is not always purely scaled. This one also has a mane of fur and tufted tail. Remember that hair should flow in the direction of the dragon, from head to tail.

>10<

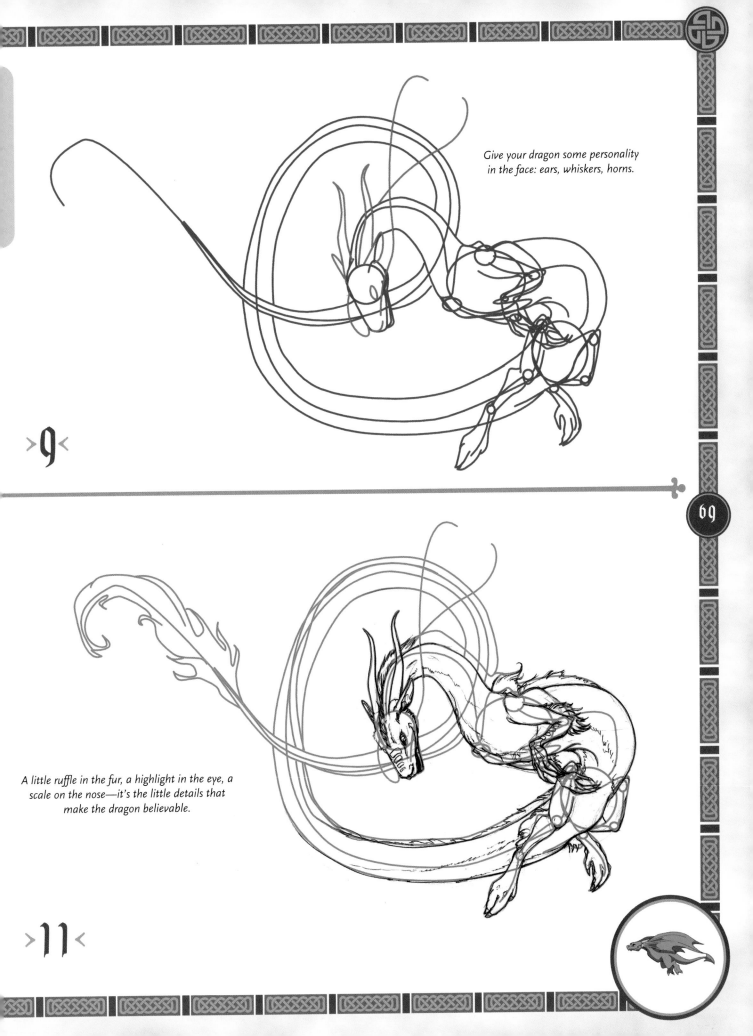

Give your dragon some personality
in the face: ears, whiskers, horns.

A little ruffle in the fur, a highlight in the eye, a
scale on the nose—it's the little details that
make the dragon believable.

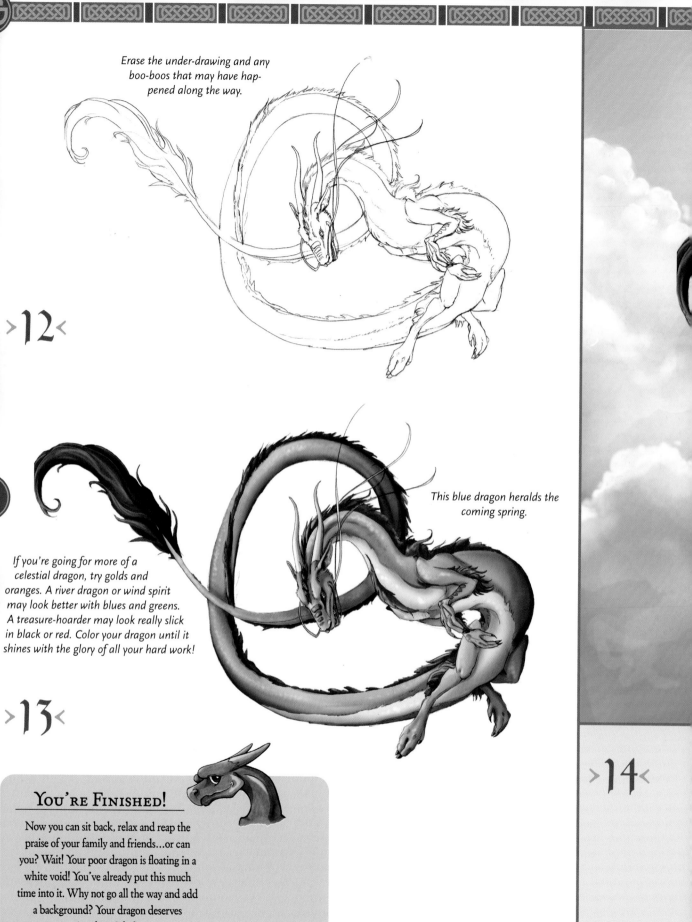

Erase the under-drawing and any boo-boos that may have happened along the way.

>12<

This blue dragon heralds the coming spring.

If you're going for more of a celestial dragon, try golds and oranges. A river dragon or wind spirit may look better with blues and greens. A treasure-hoarder may look really slick in black or red. Color your dragon until it shines with the glory of all your hard work!

>13<

>14<

YOU'RE FINISHED!

Now you can sit back, relax and reap the praise of your family and friends...or can you? Wait! Your poor dragon is floating in a white void! You've already put this much time into it. Why not go all the way and add a background? Your dragon deserves it...doesn't he?

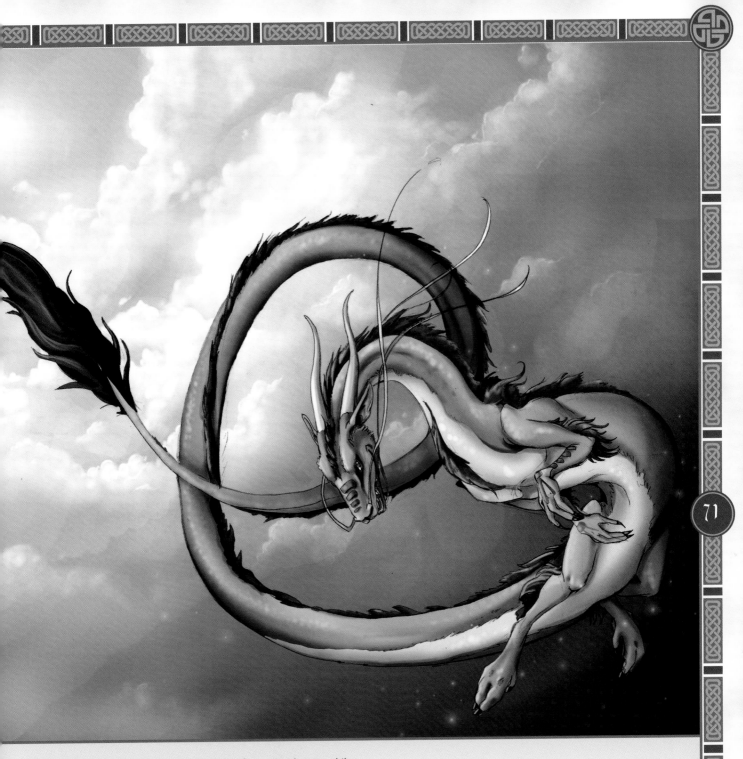

Clouds and rain may be an appropriate setting for a spirit dragon, while a big mound of treasure may be better for the more greedy dragons. A river dragon might be rising up in a great splash out of the water! Maybe you want to draw in a second dragon companion for your little guy (or gal!). When your page shines with an inner light and your dragon stays quiet, you may just have reached the finish point.

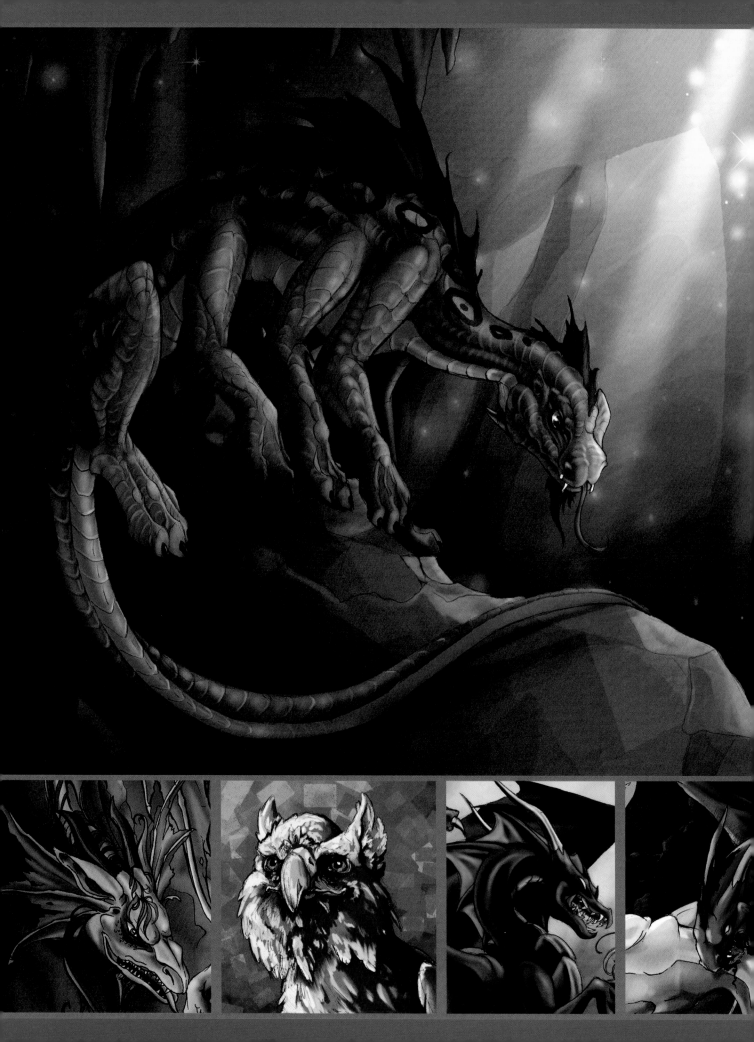

PART

2

UNIQUE DETAILS

MAKING A DRAGON OR OTHER CREATURE SPECIAL ISN'T AS EASY AS IT SEEMS.

Sure, you may think you have the world's only blue dragon with

black wings, but chances are good that someone has done it before.

To make your dragon truly unique, the important thing to remember is the

details. Things to think about.

+ *How many digits on each claw?*
+ *Does your dragon have horns?*
+ *How many horns?*
+ *What type of crest?*
+ *What does its tail look like?*
+ *Is your dragon purely scaled?*
+ *Does it have fur, hair or feathers?*

+ *What type of claw is it?*
+ *What type of horns?*
+ *Does your dragon have a crest?*
+ *Where is it placed?*
+ *What is at the end of the tail?*
+ *What is the scale pattern?*
+ *Does it have spots or stripes?*

Sure, someone else may have already created that elusive black-winged blue dragon,

but I'll bet they haven't created a black-winged blue dragon with a blue-green mane

of fur running down its body, six horns, three-taloned front feet, two-taloned back

feet and a tail tipped with a spade! To be specific is to be unique!

SPIRAL HORNS ✒ Spiral

ram-like horns make a fine addition to any beast. They can be very small or incredibly large on the head.

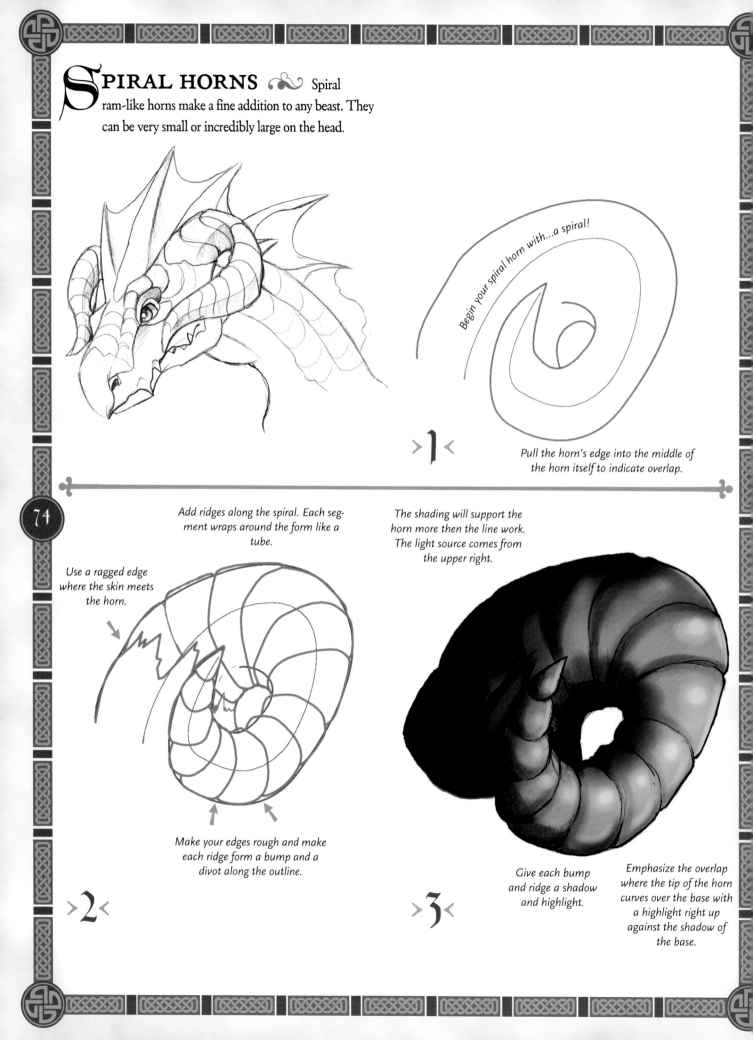

Begin your spiral horn with...a spiral!

>1<

Pull the horn's edge into the middle of the horn itself to indicate overlap.

Add ridges along the spiral. Each segment wraps around the form like a tube.

The shading will support the horn more then the line work. The light source comes from the upper right.

Use a ragged edge where the skin meets the horn.

Make your edges rough and make each ridge form a bump and a divot along the outline.

>2<

Give each bump and ridge a shadow and highlight.

Emphasize the overlap where the tip of the horn curves over the base with a highlight right up against the shadow of the base.

>3<

LONG, TUSK-LIKE HORNS

Longer, tusk-like horns are a common addition. Many of the archetypal role-playing game dragons are pictured with these horns. They can be used in sets of two, four, six, eight or...well, you get the idea.

Taper the horn towards the tip and make it thicker where it joins up with the skull.

Start with a line of motion to indicate where your horn will lay.

Add the outside edges.

>1<

Draw a jagged line at the horn's base.

Add some lines that run parallel to your outline to segment the horn.

>2<

Typically horns do not have much color as they are made up of bone. White, ivory, light brown, gray and black are the most common colors. I used an off-white for this horn.

Use highlights to give the horn a clean, shiny look. Use ovals of light to give the eye sweet spots.

SWEET SPOTS

Sweet spots? What the heck kind of term is that? I think what my human means to say is that shaping, even in highlights and shadow, does not always have to be one hundred percent accurate. Sometimes making simple, eye-pleasing shapes results in a better picture than trying to be photorealistic. Ovals of light and blocks of shadow that become shapes of their own move the eye through a picture. Look at your image as a whole and make sure there are a lot of these "sweet spots" in the places you want your viewers to pay the most attention to.

>3<

FRILLS AND FINS

Frills and fins are nearly the same. The difference lies in the function. If it's almost entirely decorative, it's a frill. If it serves a purpose, such as propulsion underwater or streamlining through the air, then it's a fin. You can place frills and fins almost anywhere on your beasts. They usually start small, get larger, and then end small, fading back into the body at either end.

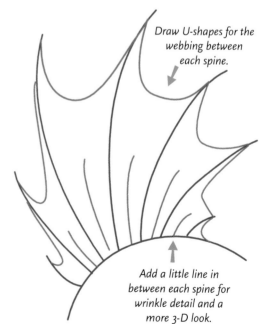

FRILL PLACEMENTS

What the heck!? You want to mess with my streamlined über-glory? Fine! Go ahead and ruin perfection. But when you do so, think about where you are placing your extras. A crest down the back, around the jaws, behind the wings, around the arms and topping the tail may be great accents for your dragon. (I just don't think it's for me.)

Draw curved lines for the spines to give your frill form and determine its size and shape.

Lines angled closer to the body create a folded look, while upright lines will make it large and flared out.

Draw U-shapes for the webbing between each spine.

Add a little line in between each spine for wrinkle detail and a more 3-D look.

>1<

>2<

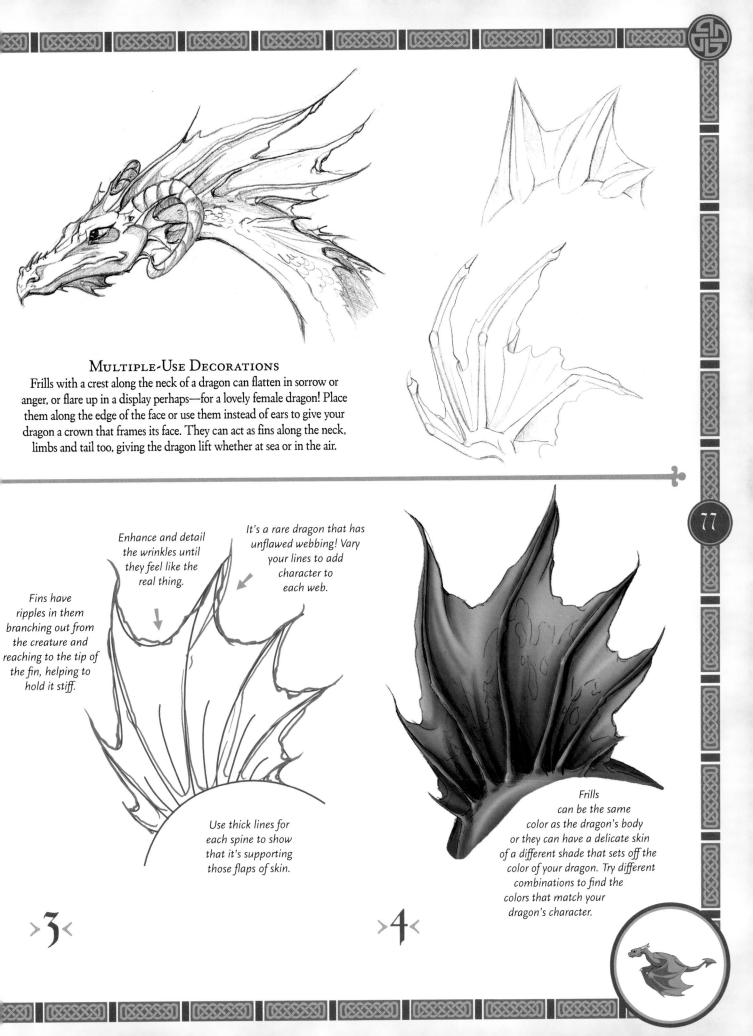

MULTIPLE-USE DECORATIONS

Frills with a crest along the neck of a dragon can flatten in sorrow or anger, or flare up in a display perhaps—for a lovely female dragon! Place them along the edge of the face or use them instead of ears to give your dragon a crown that frames its face. They can act as fins along the neck, limbs and tail too, giving the dragon lift whether at sea or in the air.

Fins have ripples in them branching out from the creature and reaching to the tip of the fin, helping to hold it stiff.

Enhance and detail the wrinkles until they feel like the real thing.

It's a rare dragon that has unflawed webbing! Vary your lines to add character to each web.

Use thick lines for each spine to show that it's supporting those flaps of skin.

Frills can be the same color as the dragon's body or they can have a delicate skin of a different shade that sets off the color of your dragon. Try different combinations to find the colors that match your dragon's character.

>3<

>4<

SCALES

Scales are the last things you should think about when creating dragons. Make sure that you have first placed down the form of your dragon. Once you have the form down, you can begin detailing pieces of it with fine scale work. Scales and patterns are a wonderful way to give your dragon personality to differentiate it from other wyrms. You can scale your dragon the same way all over or apply different scales and patterns on different areas of its body. You may want to give the underbelly a different texture from the back, for example.

WHAT KIND OF SCALES?

The scales of your dragon can either lay one on top of another or butt right up next to each other. The choice will yield two very different results, but in both cases, you will need a system for placing them down so that you don't end up with a chaotic mess scribbled across your lovely beast!

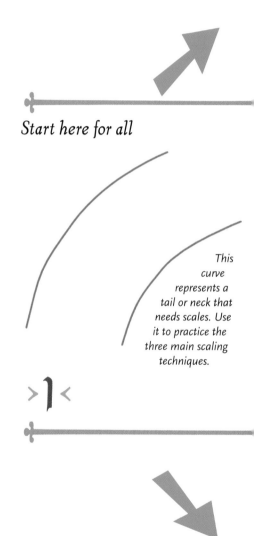

Start here for all

This curve represents a tail or neck that needs scales. Use it to practice the three main scaling techniques.

>) <

Pebble Approach

Lay in pebble-like pieces that are roughly the same size and shape for a simple, fairly uniform scale texture.

> 2 <

Each scale needs small shadow and highlight.

The whole form of the dragon will have shadow and highlight as well.

> 3 <

Curved Lines

Draw uniform curved lines that wrap around the form to create diamond-shaped scales.

Place these right against each other for a smoother appearance than overlaid scales like the pebble approach.

> 2 <

Give each scale a small shadow and highlight of its own. Remember to include the shadows that wrap around the entire form.

> 3 <

Varied Scales

Make rows of U-shaped scales of different sizes.

Draw scales of the undersides of limbs and body parts smaller than those on top.

Make sure the scales follow the flow of the creature. In most cases, they should lay pointing towards the far end.

> 2 <

You still want to shade each scale individually, keeping the entire form in mind.

Make larger scales really pop out and cast a shadow on the underbelly.

> 3 <

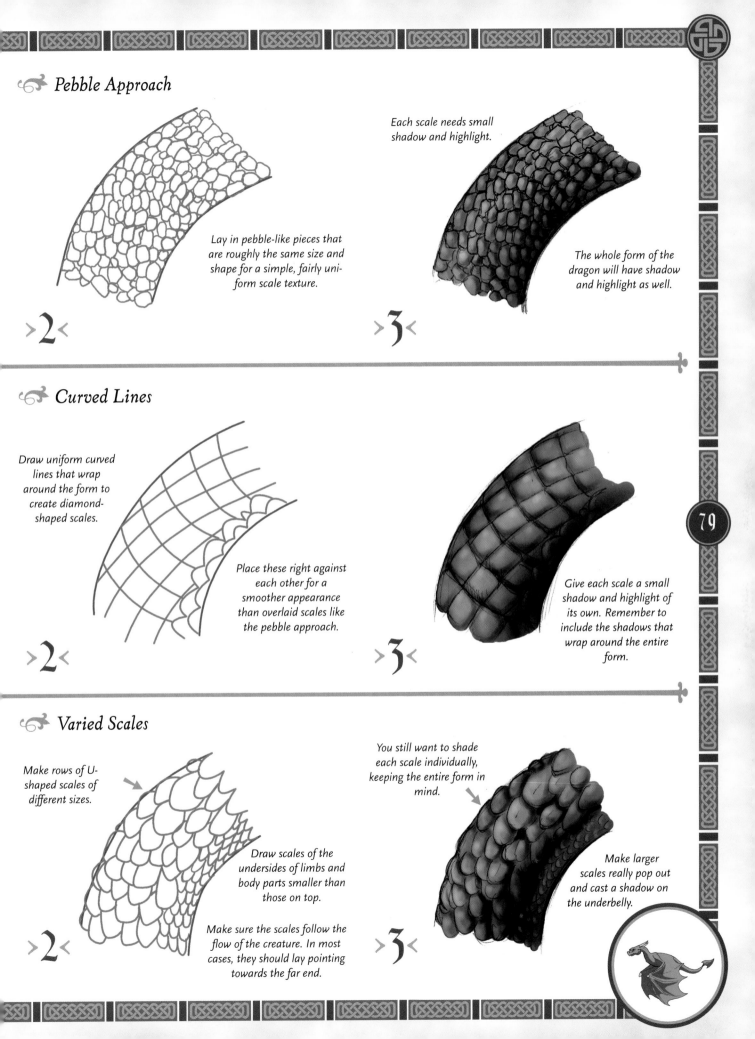

TAILS

There are as many different tails as there are dragons and beasts. There are poisonous barbs (most often found on *wyverns*, page 114), dinosaur-like tails, ox-tails (often on Eastern dragons), spade-demon tails (typical of the Western dragon), and tails purely from your own imagination.

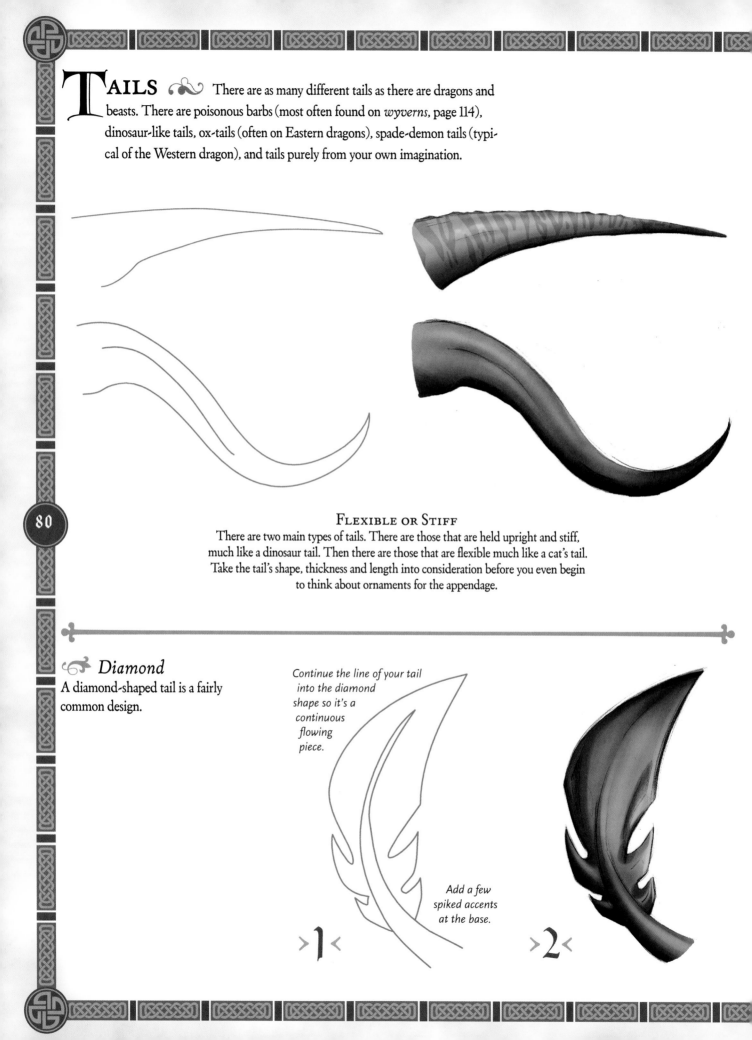

FLEXIBLE OR STIFF

There are two main types of tails. There are those that are held upright and stiff, much like a dinosaur tail. Then there are those that are flexible much like a cat's tail. Take the tail's shape, thickness and length into consideration before you even begin to think about ornaments for the appendage.

Diamond

A diamond-shaped tail is a fairly common design.

Continue the line of your tail into the diamond shape so it's a continuous flowing piece.

Add a few spiked accents at the base.

>1<

>2<

Spade

You'll find the spade tail on many types of Western dragons.

Make sure that both sides of the spade are equal in size if you do the head-on view.

>1<

>2<

Pop in a shadow at the little indent where the spade meets the main area of the tail.

Poison Barb

Common wyverns (see page 114) almost always have this tail, though it's not uncommon for dragons to have it, too. This tail bends and twists as any other would. The only difference is the venom tip. When posing creatures with this tail, have it waving threateningly overhead like a scorpion's.

>1<

>2<

Making the barb a bright color will make it look more dangerous.

Fur

If your dragon has any mane or fur on the rest of its body, you may want to end the tail with a little tuft of hair.

Work into the longer strands.

Begin the tuft with shorter pieces of hair that meet up with the base of the tail.

>1<

>2<

Include cast shadows anywhere the hairs overlap.

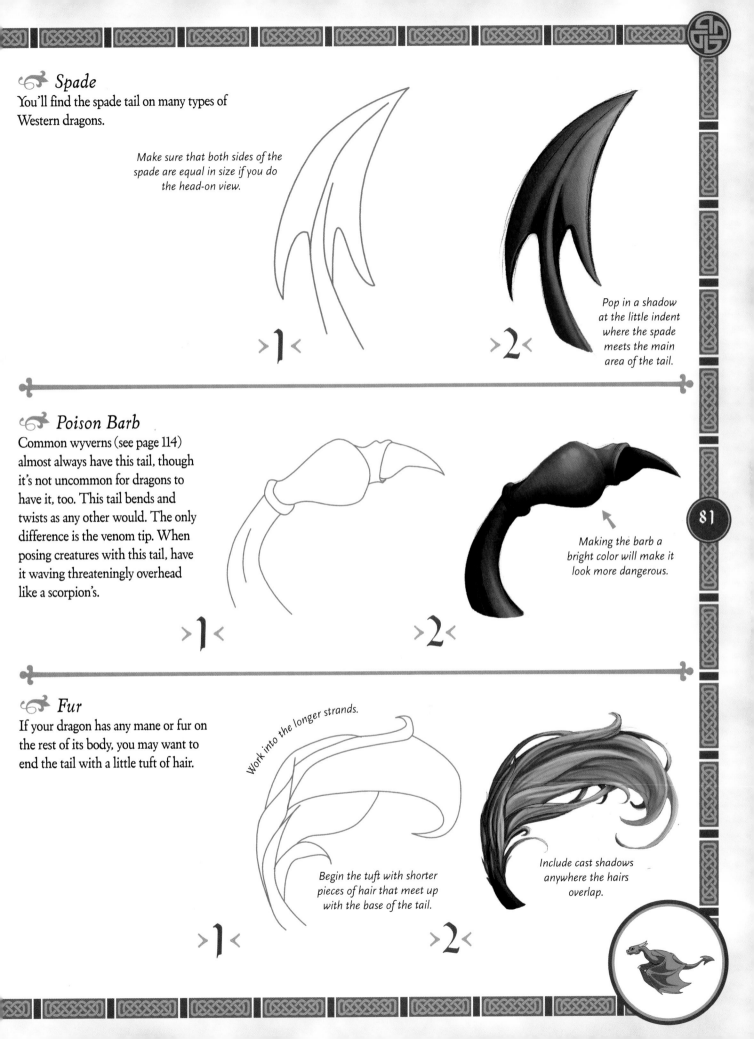

FEATHERS

Though not a common choice for most dragons, feathered wings are still found in many fantastic creatures such as the Pegasus, griffin and the phoenix. Feathered wings are made up of primary feathers and contour feathers. The primaries are the main flight feathers that stick out along the edges of the wings. They'll need more detail. The contour feathers provide overall shape for the wing. Most of the time you can represent these without a lot of detail.

Some feathers are perfectly smooth along the edges while some have a little bit of tatter. This is because the ribs that make up the soft portion of the feather zip to become a single form. Where you see the tatter is where the "zipper" has been ripped from use.

When placing the wing on your creature, take into account what happens when feathers transition to skin or scales. You may want to toss in a bit of feathery fuzz that fades out into skin across the body of your dragon to make the wing seem more natural.

WHAT'S UNDERNEATH

A wing without feathers looks like something you might cook for dinner. Like the leathery wings on pages 50–57, the structure of the wing is formed by a shoulder-elbow-wrist combination. It's over this form that feathers grow. Keep this in mind when starting the wing.

LAYERED FEATHERS FORM A WING

Begin a feathered wing just as you would any other wing. Then add the feathers as you would scales. Feathers usually consist of three basic layers. The layer closest to the top of the wing has shorter, rounder feathers. The next layer is in a neat row and is formed of longer, more sharply edged bits. The edge of the wing consists of primaries.

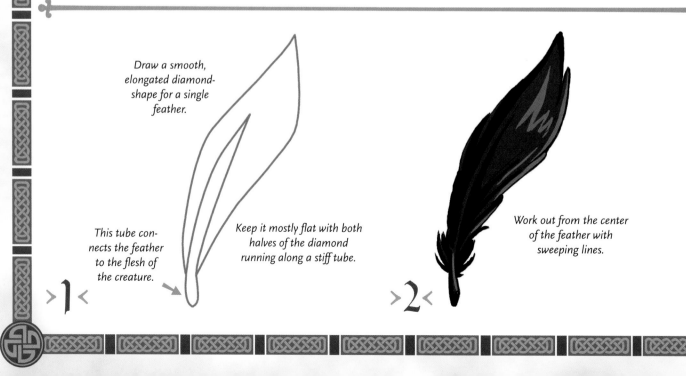

Draw a smooth, elongated diamond-shape for a single feather.

This tube connects the feather to the flesh of the creature.

Keep it mostly flat with both halves of the diamond running along a stiff tube.

Work out from the center of the feather with sweeping lines.

>1<

>2<

FUR

A coat of fur or wavy mane can make your dragon a softer, more appealing creature. Simplify your art by using line and shadow to give the illusion of fur all over without having to go crazy actually drawing those thousands of individual hairs!

FUR REFLECTS YOUR CREATURE'S HERITAGE

Dragons that live in icy climates would greatly benefit from a fine fur coat! It makes them look rather charming, too. This Blue-Furred Dragon is all cuteness and fluff until you get close enough to see the rows and rows of adorably sharp teeth.

FUR SHAPES AND DIRECTION

Keep your fur flowing in the general direction of the shape it is on. In general, the shorter the fur is, the fewer individual shapes you need to draw to get across the texture of the creature. Longer fur requires more detail.

SIMPLIFY TO FOOL THE EYE

Draw tufts of hair along the edges of all your shapes to make it appear that everything within those shapes is furred as well.

Start your long furred tail with large, general shapes that show the entire hunk of hair.

>1<

Break the large shapes into smaller chunks that flow along the same paths of motion. Pull out a couple of individual strands for texture.

>2<

Shade for additional texture, detail and a soft, layered look. Remember to add shadows anywhere that the hair overlaps.

>3<

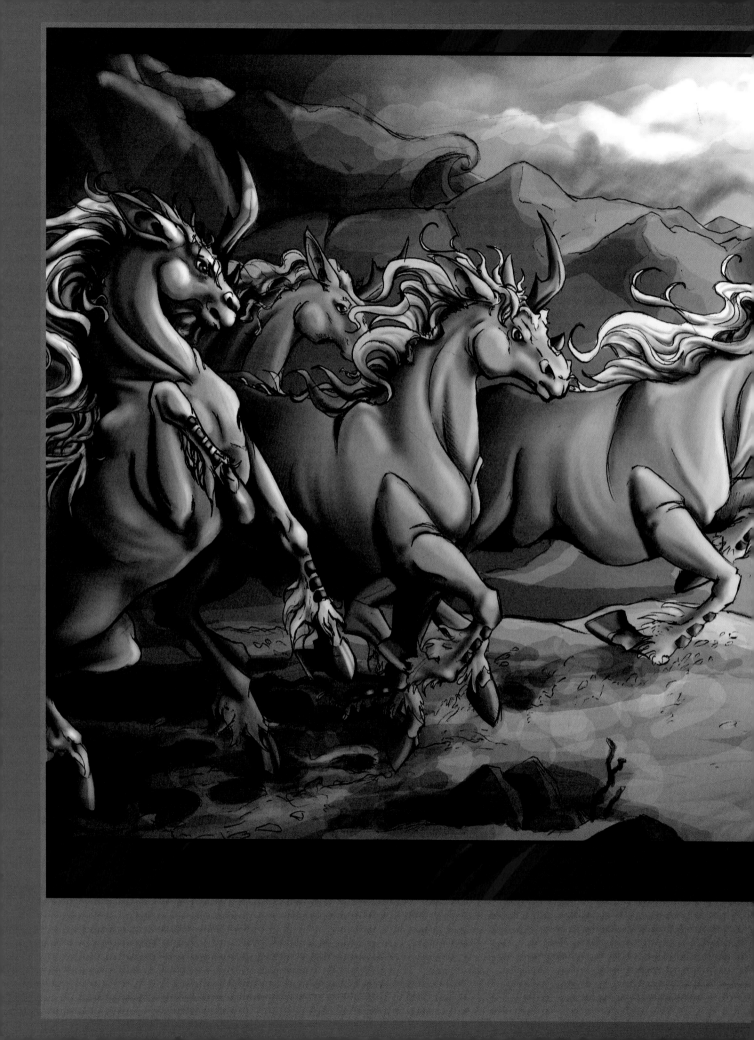

PART 3

OTHER FANTASY CREATURES

DRAGONS ARE NOT ALL THAT THERE IS TO FANTASY.

Thousands of other creatures populate the mythical universe! From wyverns, to unicorns, to the phoenix, these fantasy critters are incredibly fun to draw.

All cultures around the world have a mythology, and many of these legends are populated by fantastic beasts. Most of these creatures have a history. You can stick as close to the myth as you like when drawing them, unless straying waaaaaaaaaaaaaaaaaaaay out there is more your style! Regardless, you'll have lots of fun exploring the depths of your genius in the magical minions you create! Minions—let's try some, shall we?

GARGOYLES ✦

Gargoyles are traditionally found on medieval-type buildings. Their intended purpose is widely disputed, but common belief is that they were placed there to protect the buildings and churches and the humans inside. An important part of this mythology is that gargoyles come alive at night, presumably to better guard over their human wards.

Gargoyles come in almost every possible form, from warped-looking humans to distorted animals, to beautiful mythical beasts. This guy's a combo human-animal distortion.

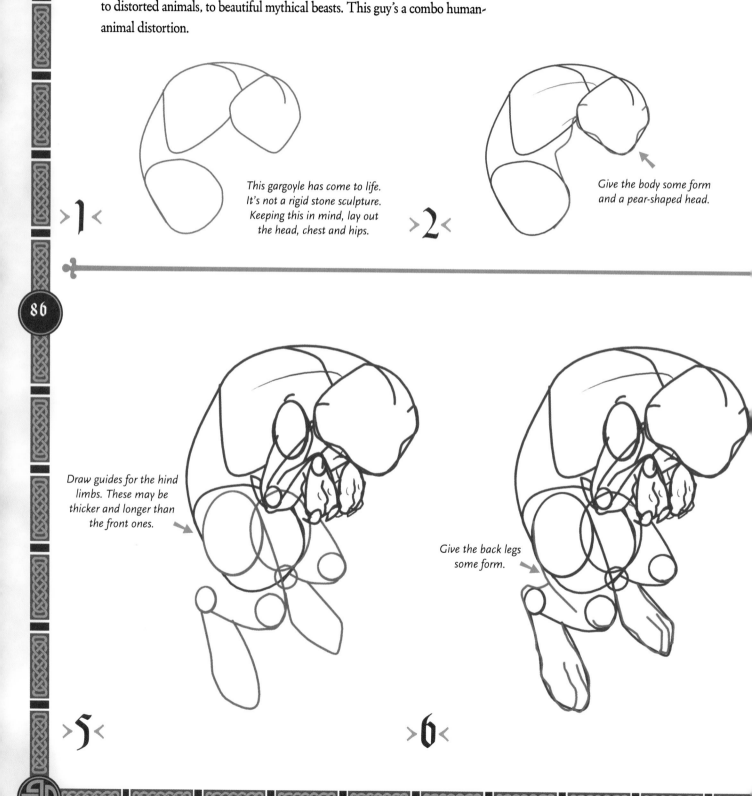

This gargoyle has come to life. It's not a rigid stone sculpture. Keeping this in mind, lay out the head, chest and hips.

> 1 <

Give the body some form and a pear-shaped head.

> 2 <

Draw guides for the hind limbs. These may be thicker and longer than the front ones.

> 5 <

Give the back legs some form.

> 6 <

The legs are tucked up close against its body while it is flying.

>3<

Give the front legs some muscle and form.

>4<

Remember to apply perspective rules. The wing farthest from us is partially hidden.

Use the same basic framework as you would for dragon wings.

MAKE YOUR GARGOYLE WINGS BELIEVABLE

Gargoyle wings can be leathery, feathery or even furry. Just remember that they should be smaller in relation to their bodies than dragon wings and the whole wing (feathers, too, if you have them) should be rather thick. Stone sculptures do not have paper-thin membrane or delicate feathers, so it follows that when the creature comes to life, the wings don't magically become delicate, wispy things.

>7<

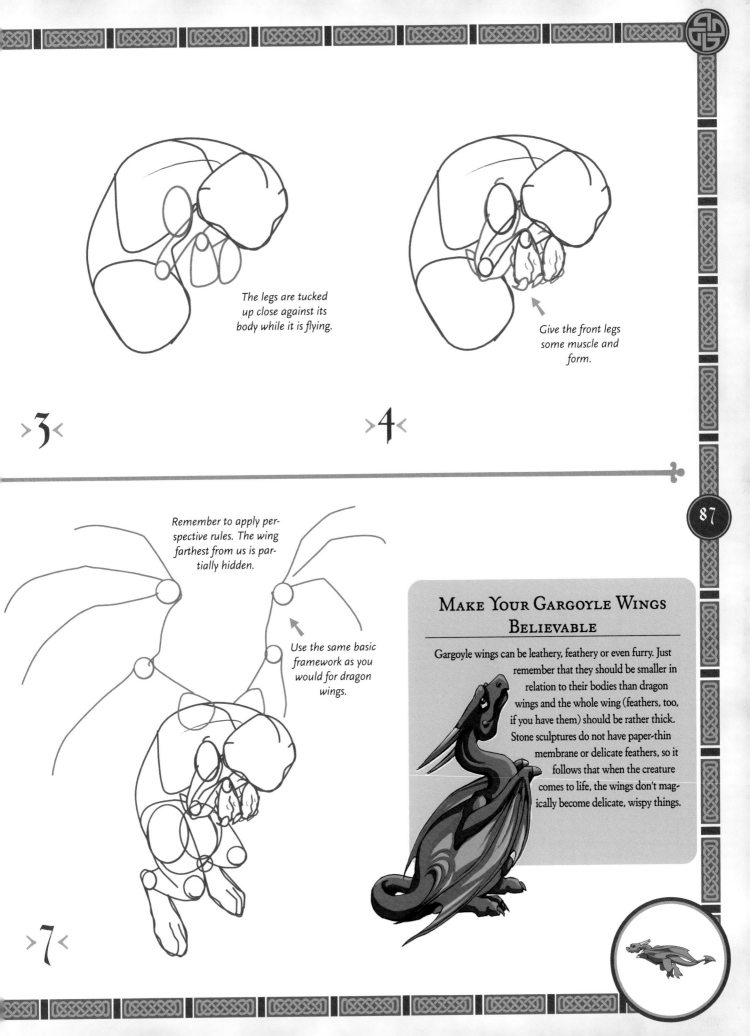

*Fill out the spines
and connect each
with webbing.*

*Make sure that
the wing trails
down the side of
the body.*

>8<

*Make the back of the
jaw the widest point
of the head.*

*Set the eyes far apart
to give the face a tri-
angular shape.*

*Gargoyles can be imp-like
creatures, lions, raptors, serpents,
or any combination in between.
Give this guy a thin beak that
widens as it goes back into the
rest of the head.*

>9<

*Gargoyles are creatures made of stone
that come to life. Using rock or earthy
colors will emphasize this.*

*Maybe the eyes are the only part
with any real life to them, or
maybe when the creature comes
to life it's a riot of color.*

>12<

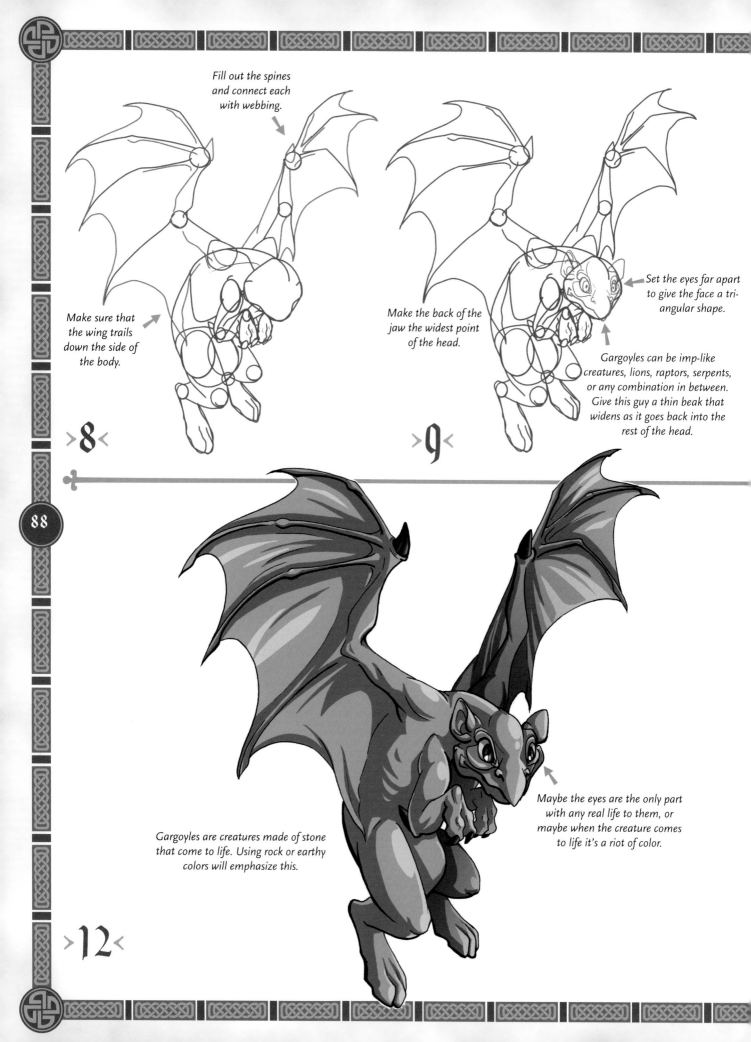

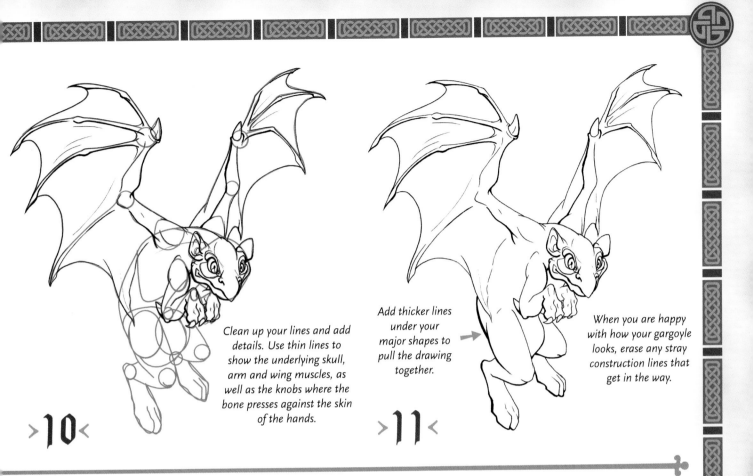

Clean up your lines and add details. Use thin lines to show the underlying skull, arm and wing muscles, as well as the knobs where the bone presses against the skin of the hands.

>10<

Add thicker lines under your major shapes to pull the drawing together.

When you are happy with how your gargoyle looks, erase any stray construction lines that get in the way.

>11<

89

GARGOYLE COLORS

Your gargoyle will probably never be as brightly colored or devastatingly handsome as myself. (Then again, this is true for almost all creatures!) Gargoyles will generally be earthy-looking, even when they have come to life. This is because of the nature of what they are. For example: You take a being of pure energy and charisma and give it shape and you get myself, in all my awesome greenness. You take something made of tightly packed particles of mud and you get more muted colors.

PEGASUS

Pegasus is a creature of Greek mythology. This winged horse sprang up from the blood of Medusa after the hero Perseus slew her. Pegasus was then captured and tamed by Bellerophon, who later rode Pegasus into a battle with the Chimera and succeeded in defeating it.

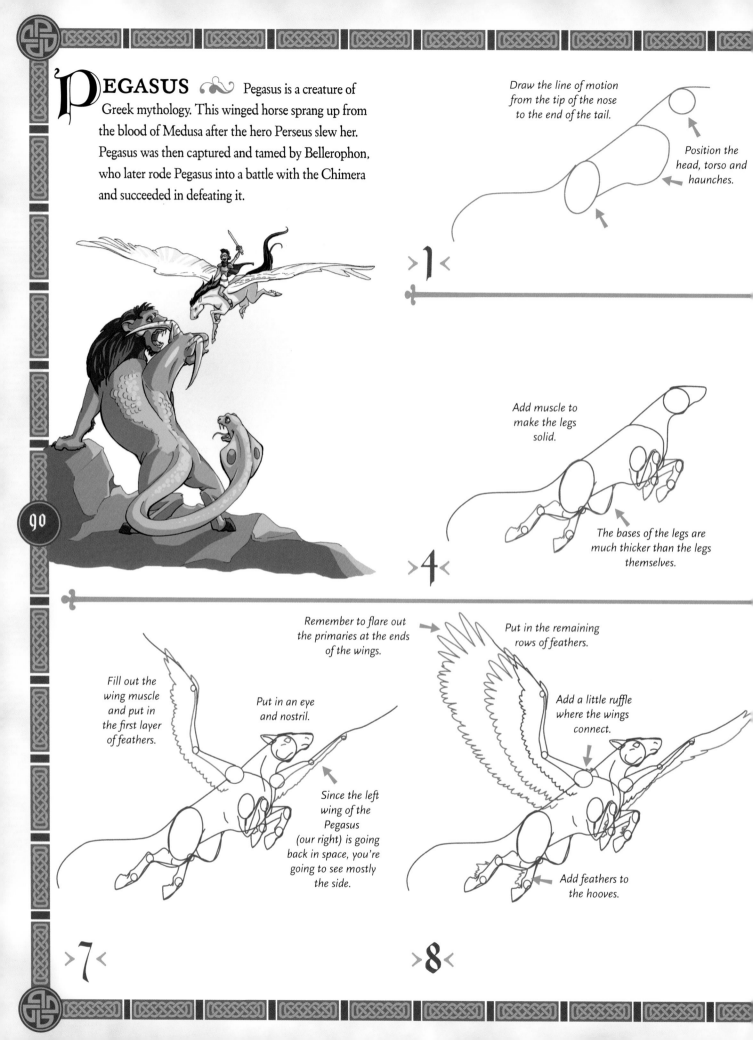

Draw the line of motion from the tip of the nose to the end of the tail.

Position the head, torso and haunches.

> 1 <

Add muscle to make the legs solid.

The bases of the legs are much thicker than the legs themselves.

> 4 <

Fill out the wing muscle and put in the first layer of feathers.

Put in an eye and nostril.

Since the left wing of the Pegasus (our right) is going back in space, you're going to see mostly the side.

> 7 <

Remember to flare out the primaries at the ends of the wings.

Put in the remaining rows of feathers.

Add a little ruffle where the wings connect.

Add feathers to the hooves.

> 8 <

>2< Indicate where the legs will emerge now so you don't overlook where they connect later.

Add the snout and take the lower line of the neck down to meet the body.

>3< Draw the basic bends and lengths of the legs.

The legs up front are folded and tucked like the horse is rearing, while the back legs are extended.

>5< Add ears.

Indicate where the muscles of the neck and rib cage will be.

Add a small mouth and a jawline. While a horse's jaw extends back, the mouth opening itself is relatively small.

>6< Draw the basic shoulder-elbow-wrist skeleton and position the wings.

TYPES OF HOOVES

The hoof is a round shape that is set slightly forward of the ankle on your veggie-munching quadruped. It will be rounded in the front and sides, but flat across the back. Treat a split hoof as two separate toes.

Whoever tied these things on me is gonna be facing some fiery wrath very, very soon...

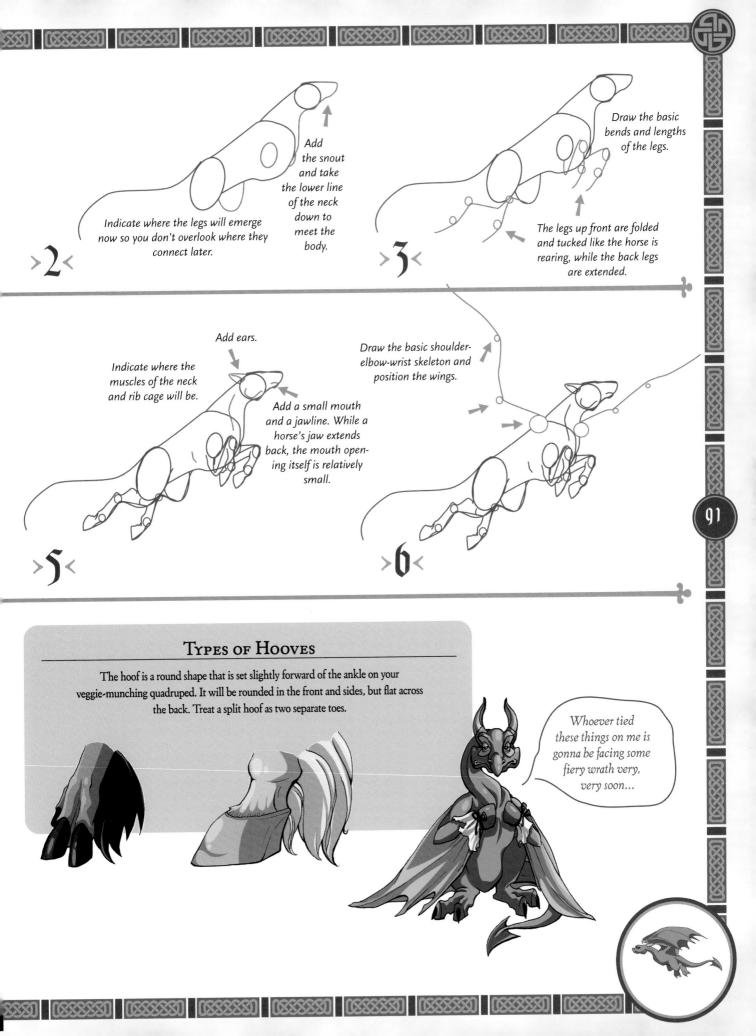

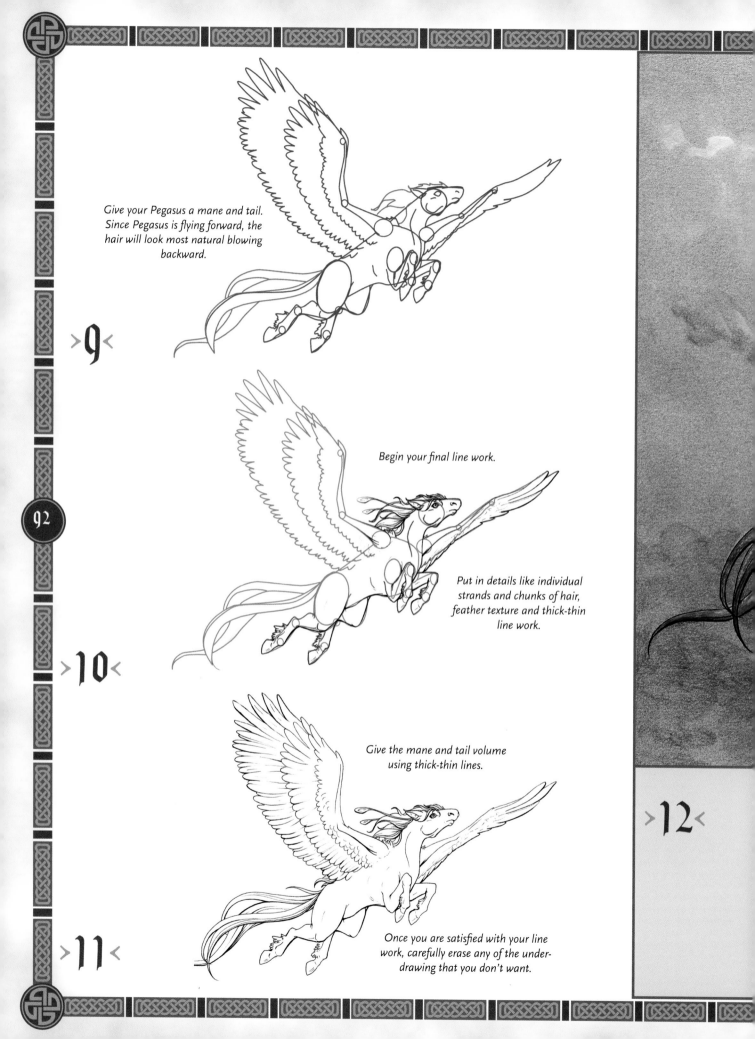

Give your Pegasus a mane and tail. Since Pegasus is flying forward, the hair will look most natural blowing backward.

>9<

Begin your final line work.

Put in details like individual strands and chunks of hair, feather texture and thick-thin line work.

>10<

Give the mane and tail volume using thick-thin lines.

Once you are satisfied with your line work, carefully erase any of the under-drawing that you don't want.

>11<

>12<

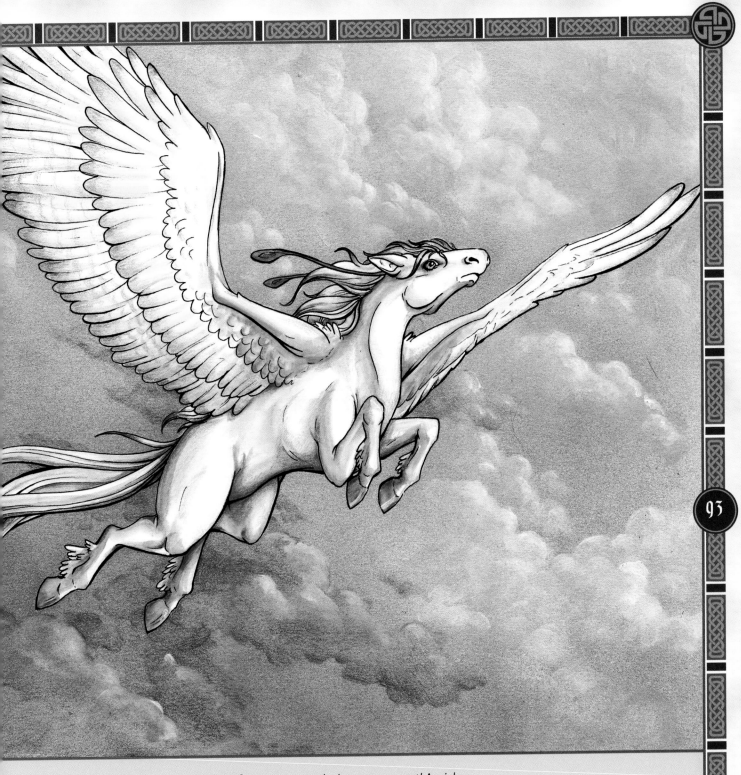

Pegasus is traditionally white, but since this is fantasy you can color however you want! A rainbow
horse may be just as interesting as a snow white one or one that is black as night.
Since Pegasus is flying, add clouds, sunset, stars or anything that shows off a lot of sky for a back-
ground. When painting or coloring in clouds, remember that the sky itself will always have a color
to it. Your clouds can be a light color on a darker sky, or dark on a brightly lit sky. Typically, the
clouds should not be darker than the backdrop during daylight hours unless there's a
looming storm.

CHIMERA

The Chimera is a fearsome beast from Greek mythology. It was an unnatural mix of lion, goat and serpent and had all three heads. The creature terrorized the region of Lycia for ages until the hero Bellerophon came riding upon Pegasus (hey, remember him?) to slay the beast from the air. Because of the flying horse's agility, the hero was able to avoid the Chimera's fiery breath and deal the fatal blow! Now, blending three things as different as a lion, a goat and a snake into one continuous creature is something that takes careful planning in advance.

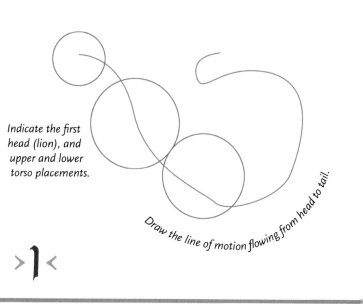

Indicate the first head (lion), and upper and lower torso placements.

Draw the line of motion flowing from head to tail.

> 1 <

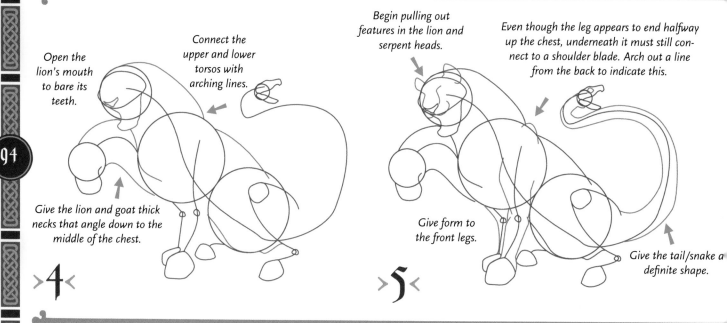

Open the lion's mouth to bare its teeth.

Connect the upper and lower torsos with arching lines.

Give the lion and goat thick necks that angle down to the middle of the chest.

> 4 <

Begin pulling out features in the lion and serpent heads.

Even though the leg appears to end halfway up the chest, underneath it must still connect to a shoulder blade. Arch out a line from the back to indicate this.

Give form to the front legs.

Give the tail/snake a definite shape.

> 5 <

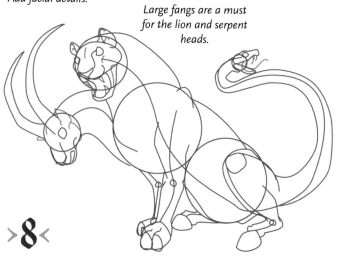

Add facial details.

Large fangs are a must for the lion and serpent heads.

> 8 <

94

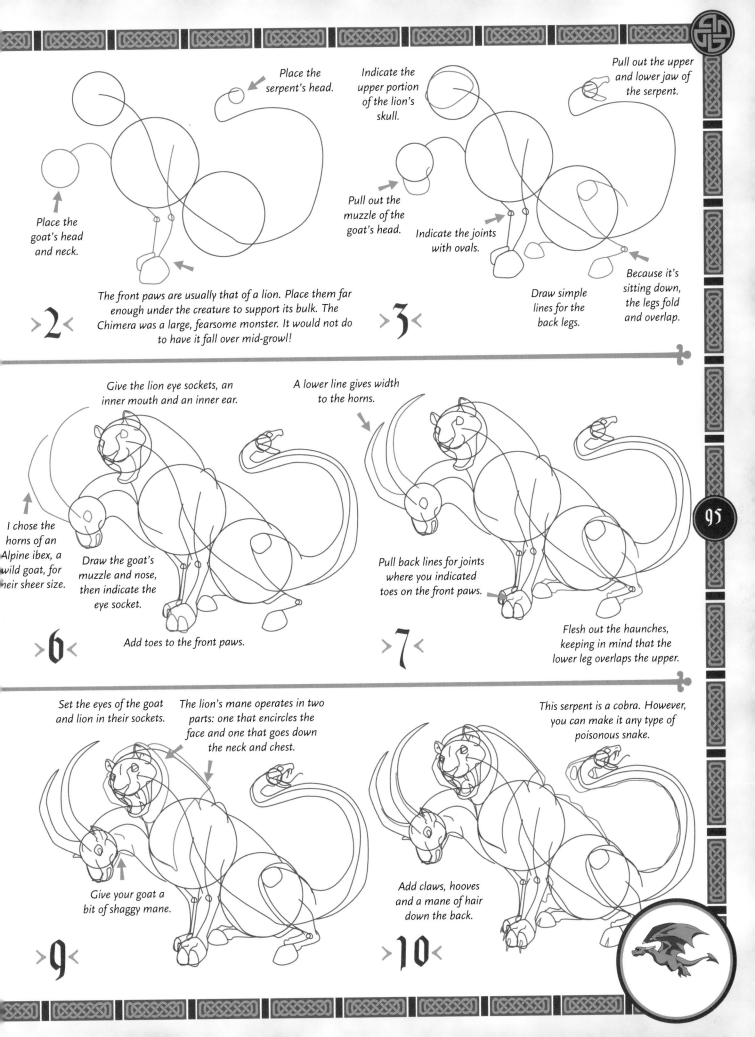

Place the serpent's head.

Indicate the upper portion of the lion's skull.

Pull out the upper and lower jaw of the serpent.

Place the goat's head and neck.

Pull out the muzzle of the goat's head.

Indicate the joints with ovals.

Because it's sitting down, the legs fold and overlap.

Draw simple lines for the back legs.

>2<

The front paws are usually that of a lion. Place them far enough under the creature to support its bulk. The Chimera was a large, fearsome monster. It would not do to have it fall over mid-growl!

>3<

Give the lion eye sockets, an inner mouth and an inner ear.

A lower line gives width to the horns.

I chose the horns of an Alpine ibex, a wild goat, for their sheer size.

Draw the goat's muzzle and nose, then indicate the eye socket.

Add toes to the front paws.

>6<

Pull back lines for joints where you indicated toes on the front paws.

Flesh out the haunches, keeping in mind that the lower leg overlaps the upper.

>7<

Set the eyes of the goat and lion in their sockets.

The lion's mane operates in two parts: one that encircles the face and one that goes down the neck and chest.

Give your goat a bit of shaggy mane.

>9<

This serpent is a cobra. However, you can make it any type of poisonous snake.

Add claws, hooves and a mane of hair down the back.

>10<

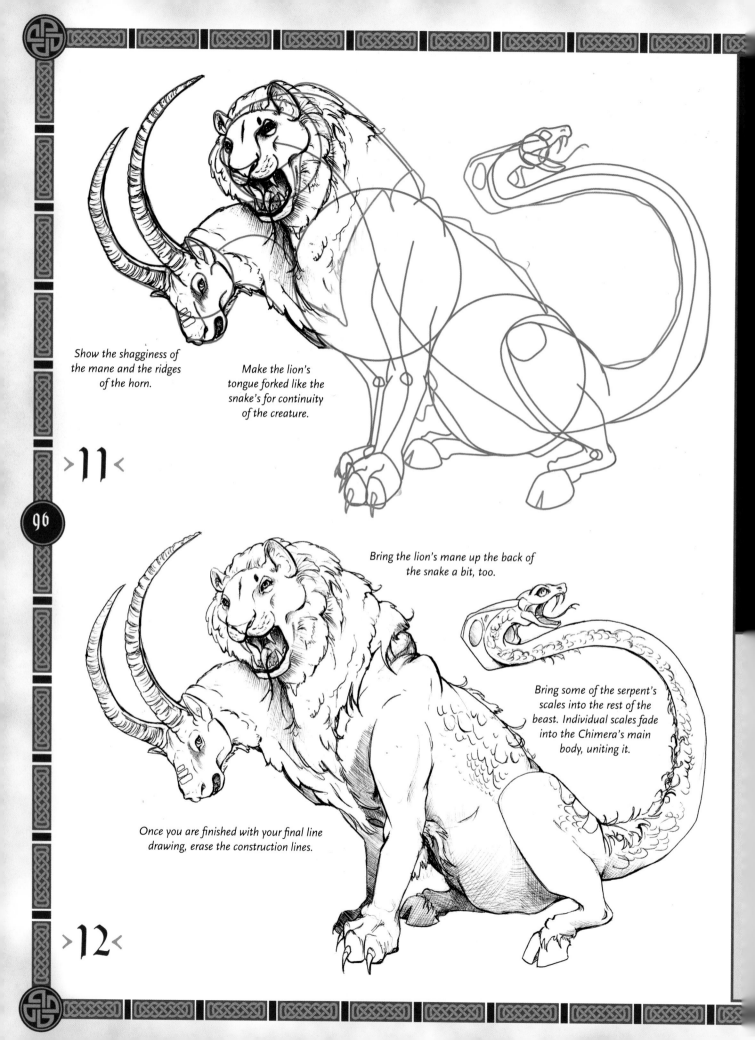

Show the shagginess of
the mane and the ridges
of the horn.

Make the lion's
tongue forked like the
snake's for continuity
of the creature.

>11<

Bring the lion's mane up the back of
the snake a bit, too.

Bring some of the serpent's
scales into the rest of the
beast. Individual scales fade
into the Chimera's main
body, uniting it.

Once you are finished with your final line
drawing, erase the construction lines.

>12<

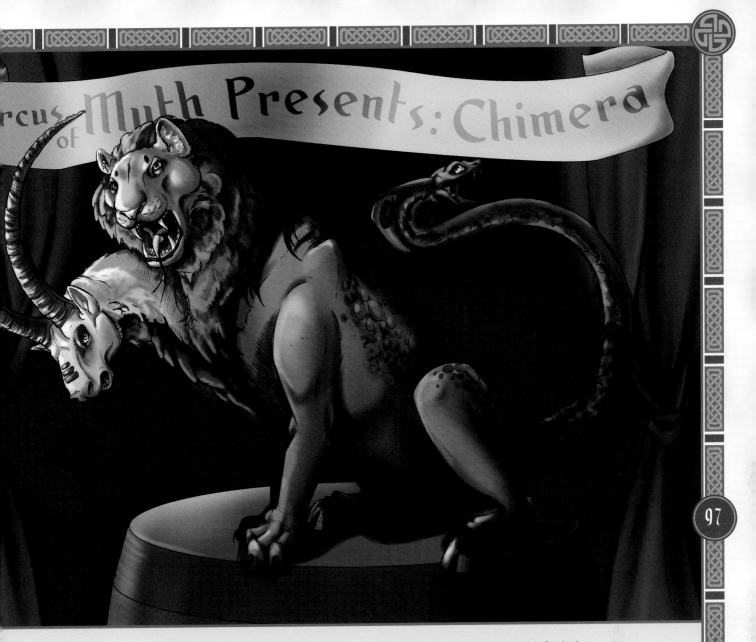

Circus of Myth Presents: Chimera

>13<

I used naturalistic colors for my Chimera, but since this is a creature of myth, there's no saying that it can't be red with a fiery mane or a sickly green.

An environment makes your work a finished piece of art. This guy's imprisoned in a circus of myth, but he could also be set in Lycia, terrorizing the local peasants. The choices are endless!.

KIRIN (CHINESE UNICORN)

Like the unicorn, the Eastern-based kirin is a creature that appears to those with great virtue. The kirin is an animal god with the horn of a deer, the scales of a carp and the tail of an ox.

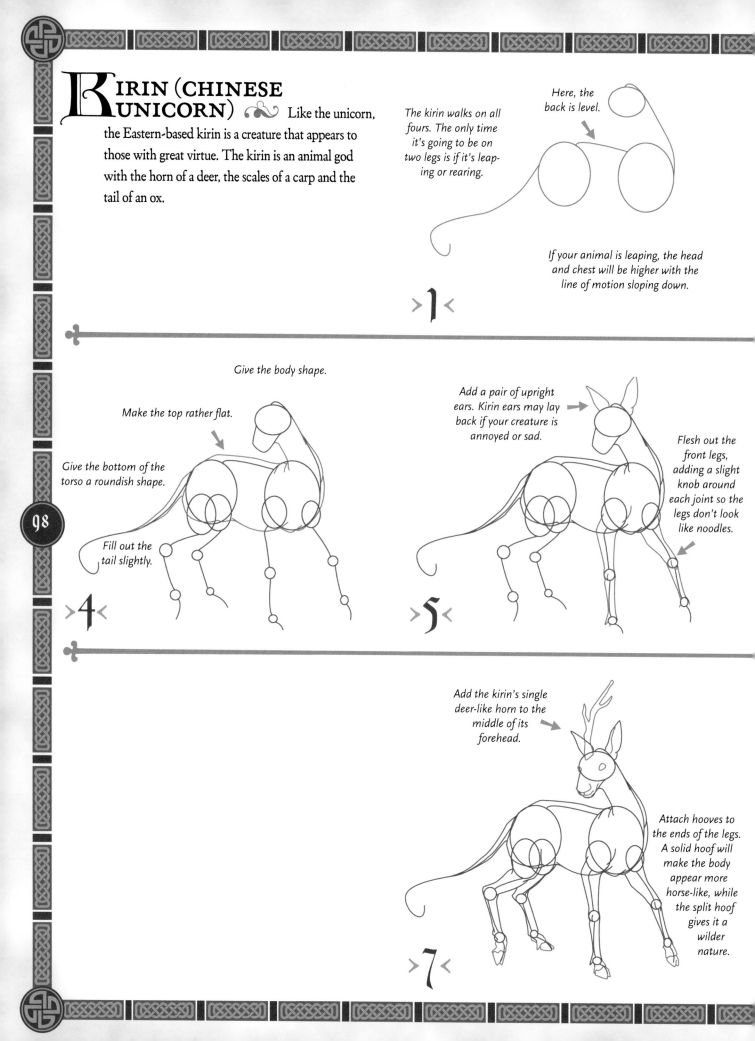

The kirin walks on all fours. The only time it's going to be on two legs is if it's leaping or rearing.

Here, the back is level.

> 1 <

If your animal is leaping, the head and chest will be higher with the line of motion sloping down.

Give the body shape.

Make the top rather flat.

Give the bottom of the torso a roundish shape.

Fill out the tail slightly.

> 4 <

Add a pair of upright ears. Kirin ears may lay back if your creature is annoyed or sad.

Flesh out the front legs, adding a slight knob around each joint so the legs don't look like noodles.

> 5 <

Add the kirin's single deer-like horn to the middle of its forehead.

Attach hooves to the ends of the legs. A solid hoof will make the body appear more horse-like, while the split hoof gives it a wilder nature.

> 7 <

98

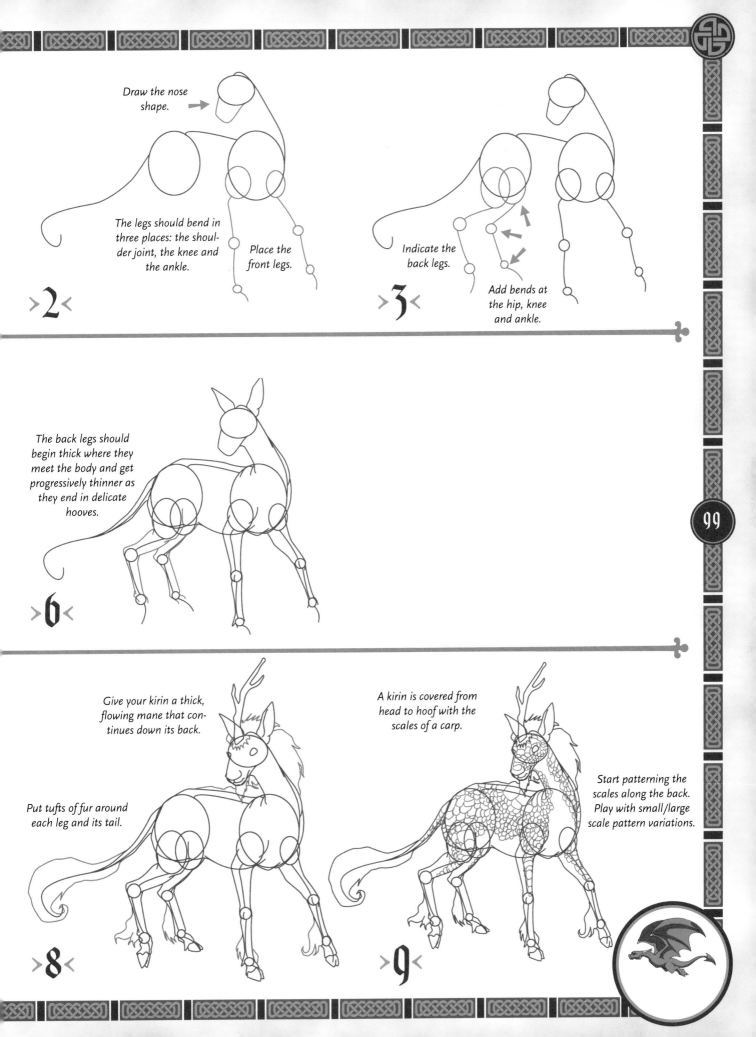

Draw the nose shape.

The legs should bend in three places: the shoulder joint, the knee and the ankle.

Place the front legs.

>2<

Indicate the back legs.

Add bends at the hip, knee and ankle.

>3<

The back legs should begin thick where they meet the body and get progressively thinner as they end in delicate hooves.

>6<

Give your kirin a thick, flowing mane that continues down its back.

Put tufts of fur around each leg and its tail.

>8<

A kirin is covered from head to hoof with the scales of a carp.

Start patterning the scales along the back. Play with small/large scale pattern variations.

>9<

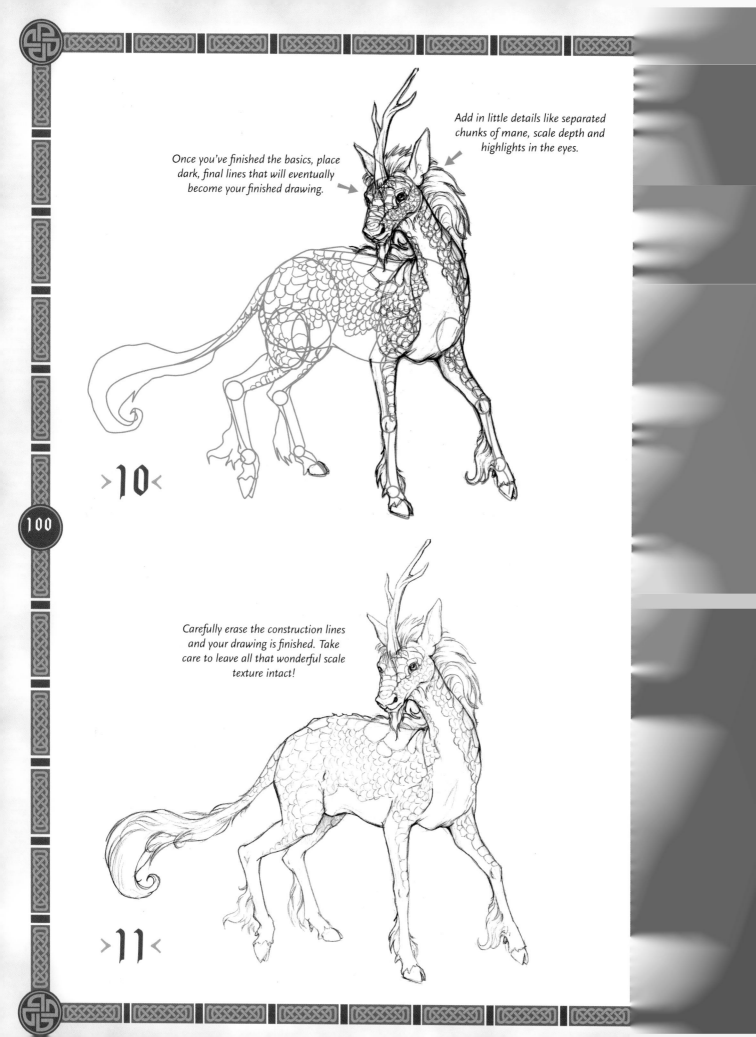

Once you've finished the basics, place dark, final lines that will eventually become your finished drawing.

Add in little details like separated chunks of mane, scale depth and highlights in the eyes.

>10<

100

Carefully erase the construction lines and your drawing is finished. Take care to leave all that wonderful scale texture intact!

>11<

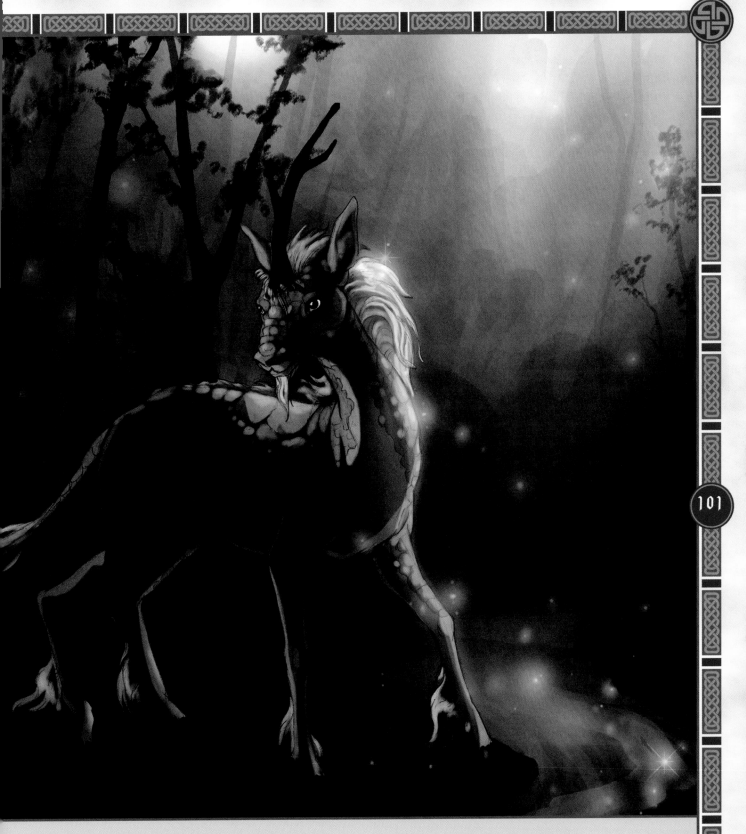

The setting in which you place your kirin will impact its feel also, so choose carefully, whether your kirin is traversing a shady glen, running among the clouds or picking its way through the remains of a battlefield. A backlit setting like this one leaves most of what's facing us in shadow and provides a fine excuse for glow around the edges. A single light source can be dramatic!

This is a magical creature. Give each scale its own little highlight to show that magic. You have a lot of color choices to make, too. Carp scales are pink and brown, but you can make them almost any color you like. Maybe they'll be pearly white or pearly green.

PHOENIX (FIREBIRD)

An ancient symbol of renewal, the legend of the phoenix was present in both Arabian and Chinese cultures, though the bird symbolized different things to each. Arabian mythology tells us that the phoenix was as large as an eagle with a melodious cry. The greatest characteristic of the bird is its renewal by fire. In China the bird was a symbol of morality. It was a gentle creature that would not needlessly destroy and ate only dewdrops. The plumage of the Chinese and Arabian phoenix differs greatly. The Arabian phoenix is usually decked out in reds and golds, while the Chinese bird has an array of black, white, yellow, green and red feathers.

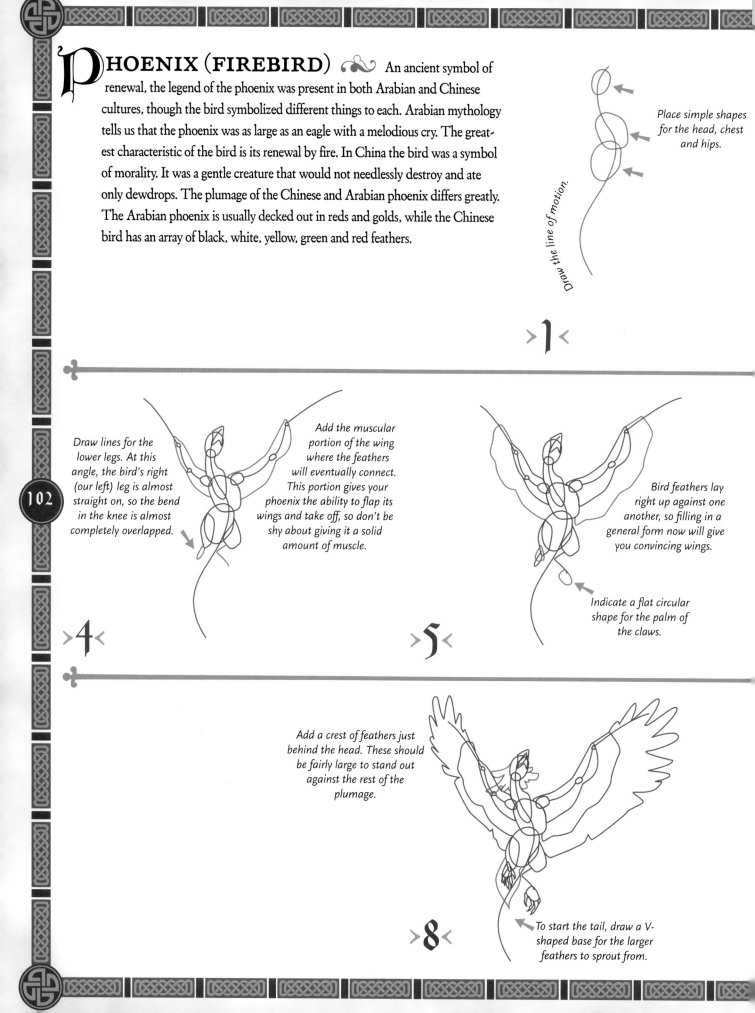

Place simple shapes for the head, chest and hips.

Draw the line of motion.

>1<

Draw lines for the lower legs. At this angle, the bird's right (our left) leg is almost straight on, so the bend in the knee is almost completely overlapped.

Add the muscular portion of the wing where the feathers will eventually connect. This portion gives your phoenix the ability to flap its wings and take off, so don't be shy about giving it a solid amount of muscle.

>4<

Bird feathers lay right up against one another, so filling in a general form now will give you convincing wings.

Indicate a flat circular shape for the palm of the claws.

>5<

Add a crest of feathers just behind the head. These should be fairly large to stand out against the rest of the plumage.

>8<

To start the tail, draw a V-shaped base for the larger feathers to sprout from.

Lay in the framework for the outstretched wings of a bird rising in flight.

Indicate the shoulder, elbow and wrist of the wing. If you indicate the wings after you've completely drawn the body of the bird, they will look pasted on.

>2<

Turn the beak's triangle shapes with the head.

Draw the shape of the neck widest where it joins the body and tapered just before it meets up with the head.

Place the shapes for the thighs. This is a large bird and will need large, predatory legs for support.

>3<

Primaries flare at the tips.

Feathers are closer together near the body.

Draw a second row of feathers. Layered feathers help make bird wings look natural.

>6<

Separate the upper and lower jaw. The upper jaw is larger than the lower one, but at this angle they should appear equal in size.

Draw a single back claw and three toes on each limb.

>7<

To complete the legs, draw two lines bending at angles. The upper leg will be thicker and taper into the lower one.

Finish off the tail with a larger, more flowing V-shape to indicate the long, large feathers.

>9<

Give your phoenix an eye.

To keep things exotic, add some peacock-like feathers.

>10<

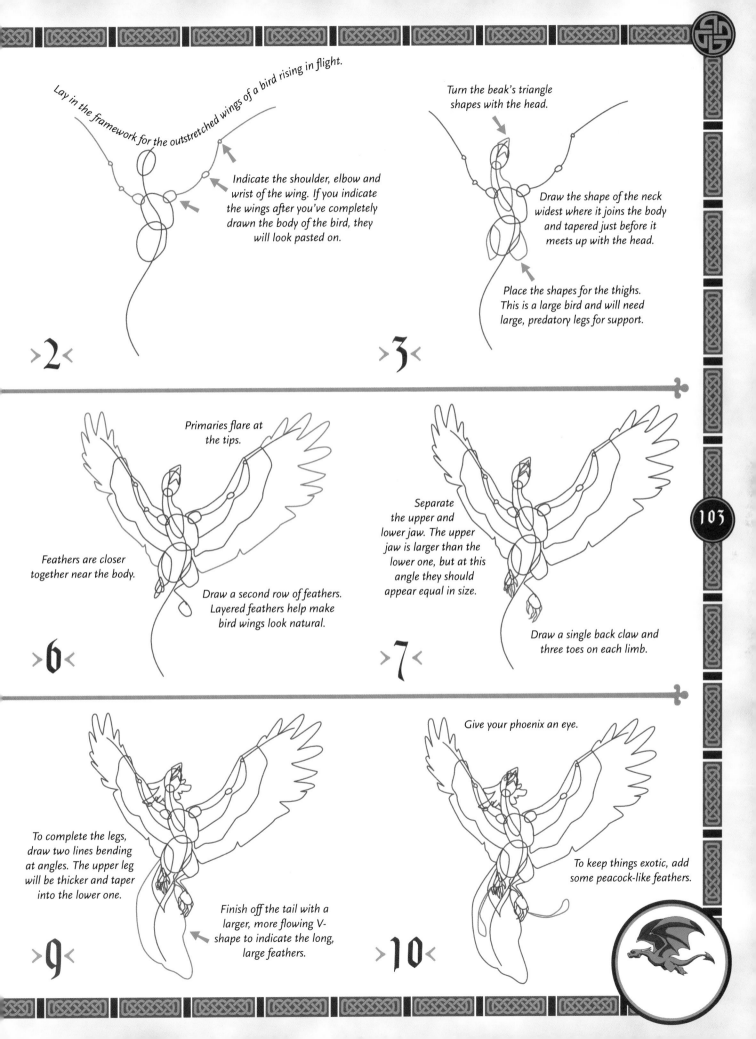

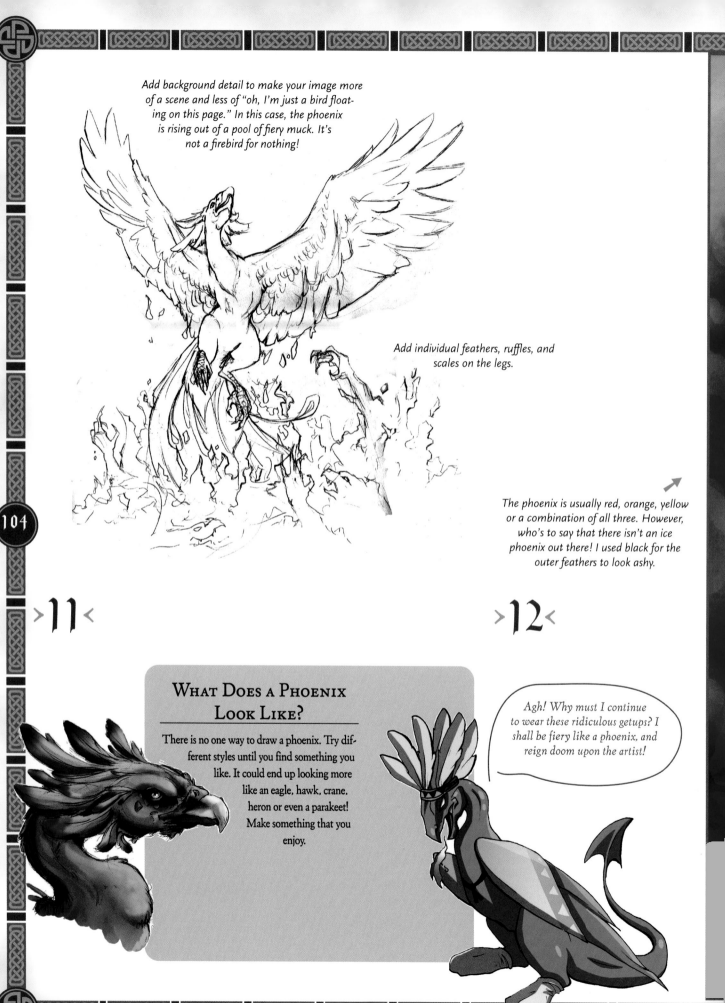

Add background detail to make your image more of a scene and less of "oh, I'm just a bird floating on this page." In this case, the phoenix is rising out of a pool of fiery muck. It's not a firebird for nothing!

Add individual feathers, ruffles, and scales on the legs.

The phoenix is usually red, orange, yellow or a combination of all three. However, who's to say that there isn't an ice phoenix out there! I used black for the outer feathers to look ashy.

>11<

>12<

WHAT DOES A PHOENIX LOOK LIKE?

There is no one way to draw a phoenix. Try different styles until you find something you like. It could end up looking more like an eagle, hawk, crane, heron or even a parakeet! Make something that you enjoy.

Agh! Why must I continue to wear these ridiculous getups? I shall be fiery like a phoenix, and reign doom upon the artist!

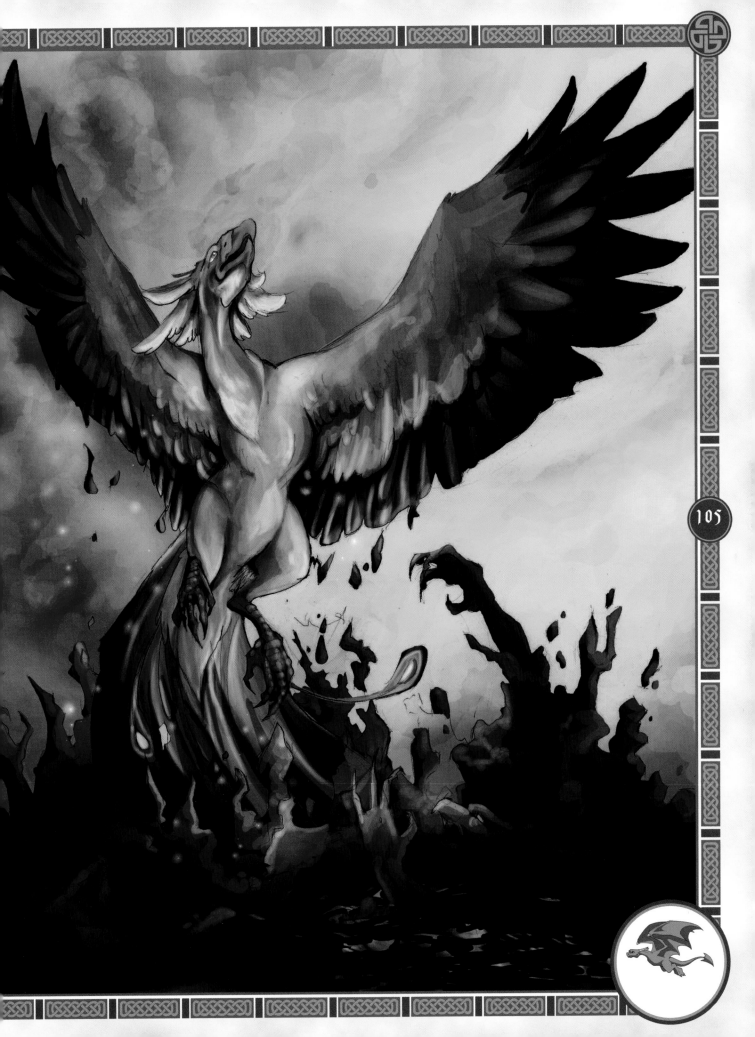

GRIFFINS

Griffins (or gryphons, as they are also referred to) are common creatures of myth and popular heraldic symbols. According to Greek myth, these part-eagle, part-lion creatures loved treasure. They became a common guardianship symbol in the Middle Ages in the form of griffin-shaped gargoyles.

Draw a line of motion with circles to indicate the head, and the upper and lower torso.

>1<

Review pages 30–37 to draw the basic structures of the legs.

This griffin's hindquarters are on the ground, so the fold the back leg in.

>4<

Much of the back wing is obstructed by the body, so do your best guesti-mate to determine how it connects.

Branch very simple wing shapes off the connection points. Fold the wings over the body.

>5<

Begin adding layers of plumage to the wings. A few simple ruffles can indicate a lot, so don't go crazy or the wings will become distracting.

Give the tail two layers of feathers.

>8<

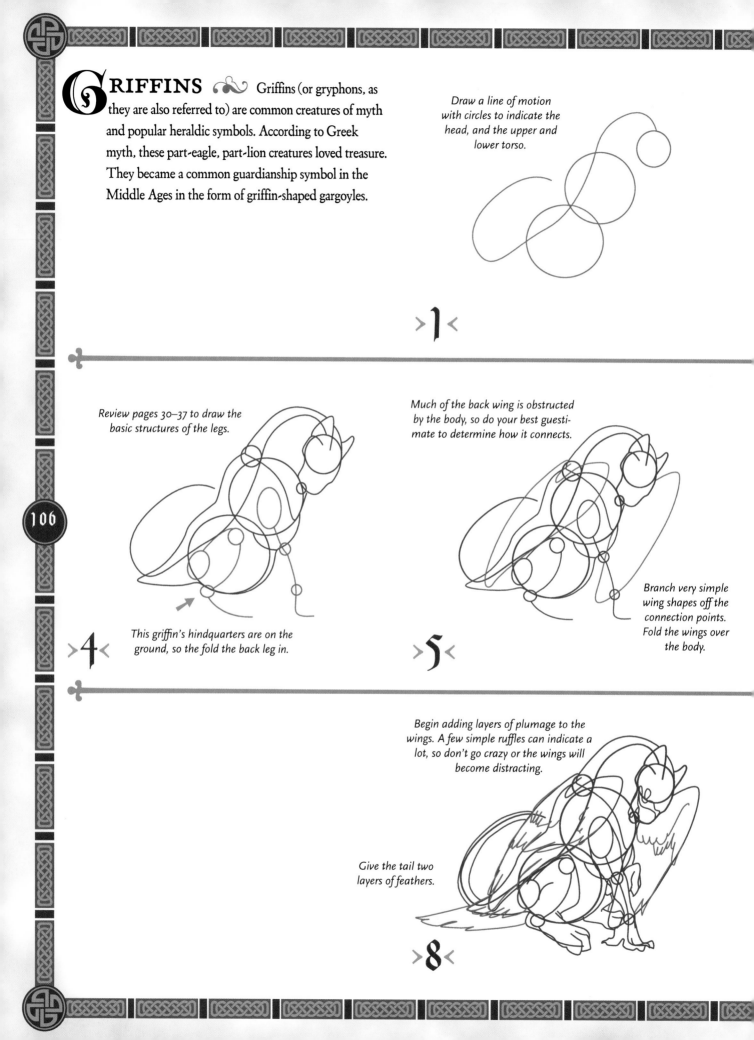

Add ears and two circles to indicate where the wings will meet the body. Remember, in this 3/4 view, objects closer to you will appear larger than their twins on the other side.

Draw simple lines for the basic head and beak shape.

>2<

Connect the head to the body with a thick neck that ends in a V-shape. This shape marks the end of the feathers and the beginning of the lion portion.

Connect both portions of the torso and end with another V-shape to mark the base of the tail.

>3<

Griffin back legs are usually those of a lion, while the front are usually those of an eagle. Flesh out the limbs using what you learned about paws on pages 38–39 and talon-like claws on pages 40–41.

It is your griffin though, so you can make all four limbs lion or all four eagle. Maybe they are reversed. Maybe they aren't claws at all!

>6<

Add a lion's tail that peeks out from under the bird's.

Pull out a separate upper and lower jaw.

Place an eye pretty close to the beak itself.

Finish off the last leg.

>7<

Give the head some layers of soft feathers to add texture.

Add scales and more feathers for the front leg.

Place claws for those hind feet.

>9<

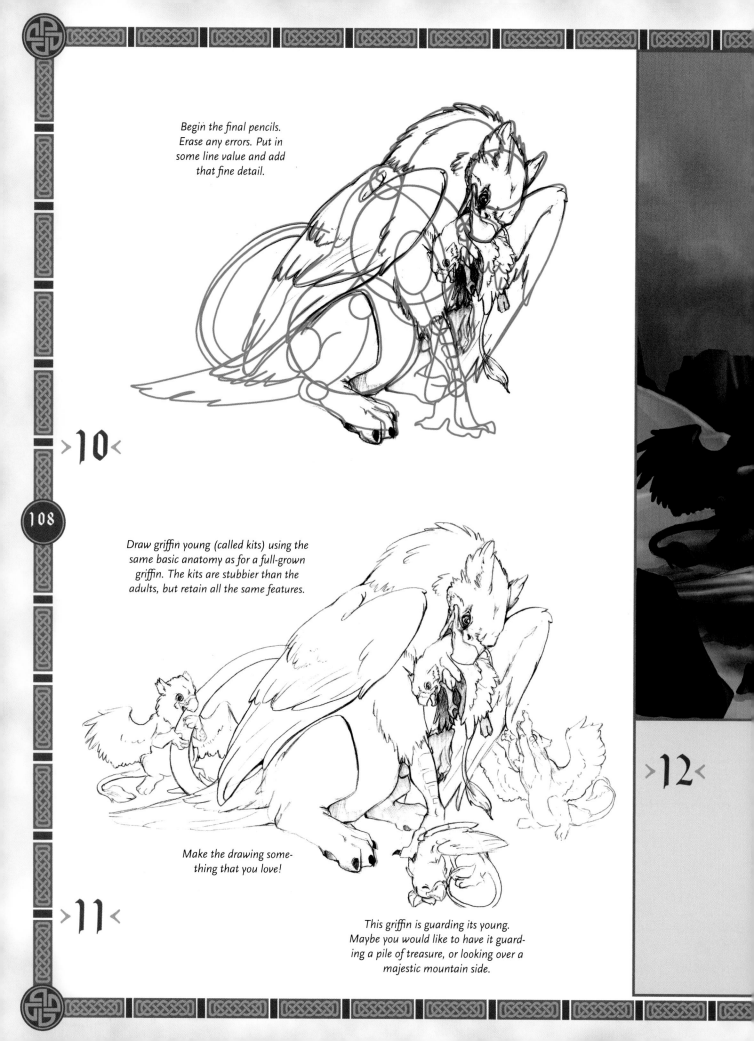

Begin the final pencils. Erase any errors. Put in some line value and add that fine detail.

>10<

Draw griffin young (called kits) using the same basic anatomy as for a full-grown griffin. The kits are stubbier than the adults, but retain all the same features.

Make the drawing something that you love!

>11<

This griffin is guarding its young. Maybe you would like to have it guarding a pile of treasure, or looking over a majestic mountain side.

>12<

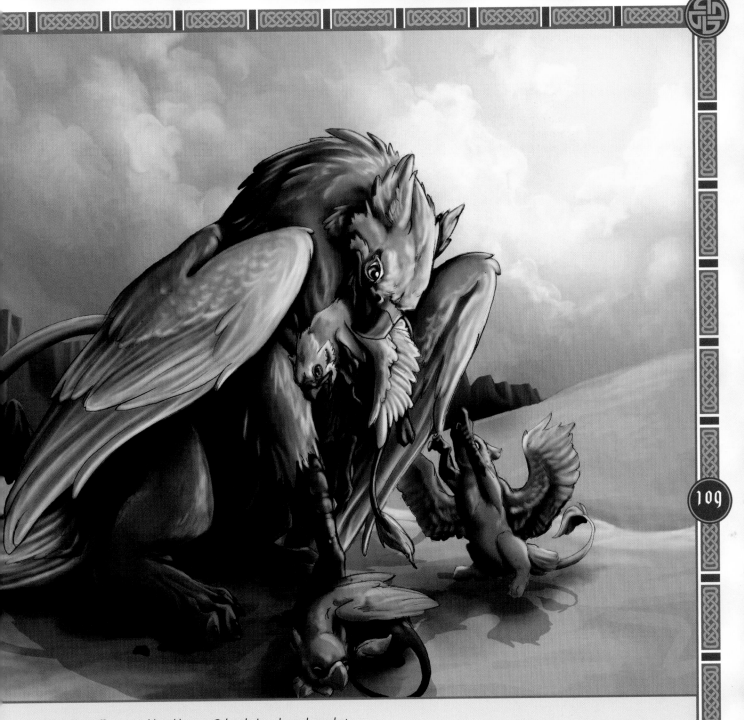

Traditionally, griffins are gold and brown. Color choices depend on what breed of griffin you have created. If you have a raven/tiger mix, the colors are different from those of an eagle/lion. Try different combinations of big cats and birds of prey. Or maybe your griffin isn't large at all! It might be fun to play around with something more domestic, like a house cat/parrot combination.

BASILISK

Basilisks are unusual fantasy creatures. Not only do they have very different forms, they also have two different abilities: lethal breath and lethal stare. Their breath will kill you and their gaze will turn you to stone. In many myths, the creature is a mix of serpent and a chicken. In fantasy worlds like *Dungeons & Dragons*, the creature is defined as a serpent with eight legs. In *Harry Potter*, it is simply a very large serpent with a gaze that kills.

Draw a long serpent with markers for the head, chest and hips.

> 1 <

Give the legs a bit of thickness and a sense of the underlying muscle.

Think about the different types of legs. Some sets of legs will bend like hind legs.

Some behave more like front limbs.

> 4 <

Give your basilisk a set of lizard-like paws to match its winning personality.

When the front legs and paws are largely finished, draw in between them to show what's going on with the legs on the other side. Since they are farther away and likely in shadow, these don't need very much detail.

> 5 <

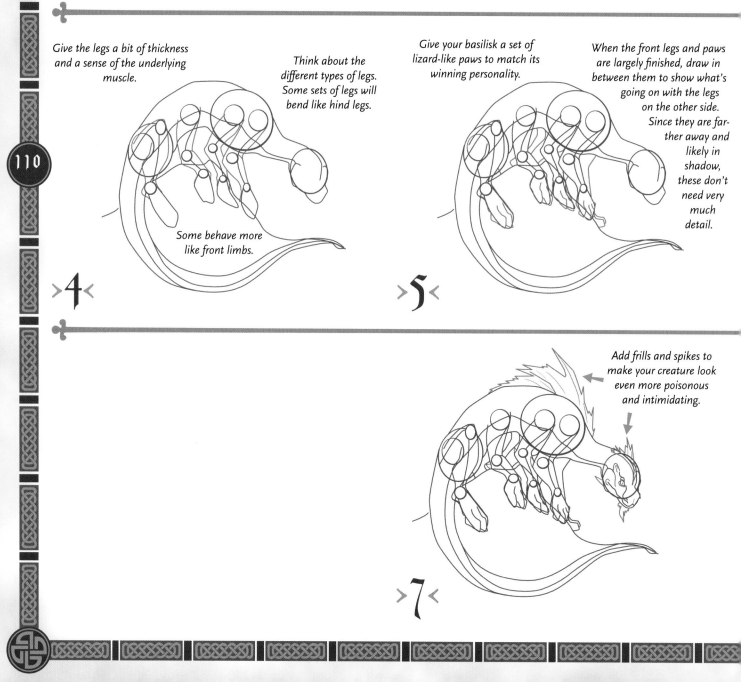

Add frills and spikes to make your creature look even more poisonous and intimidating.

> 7 <

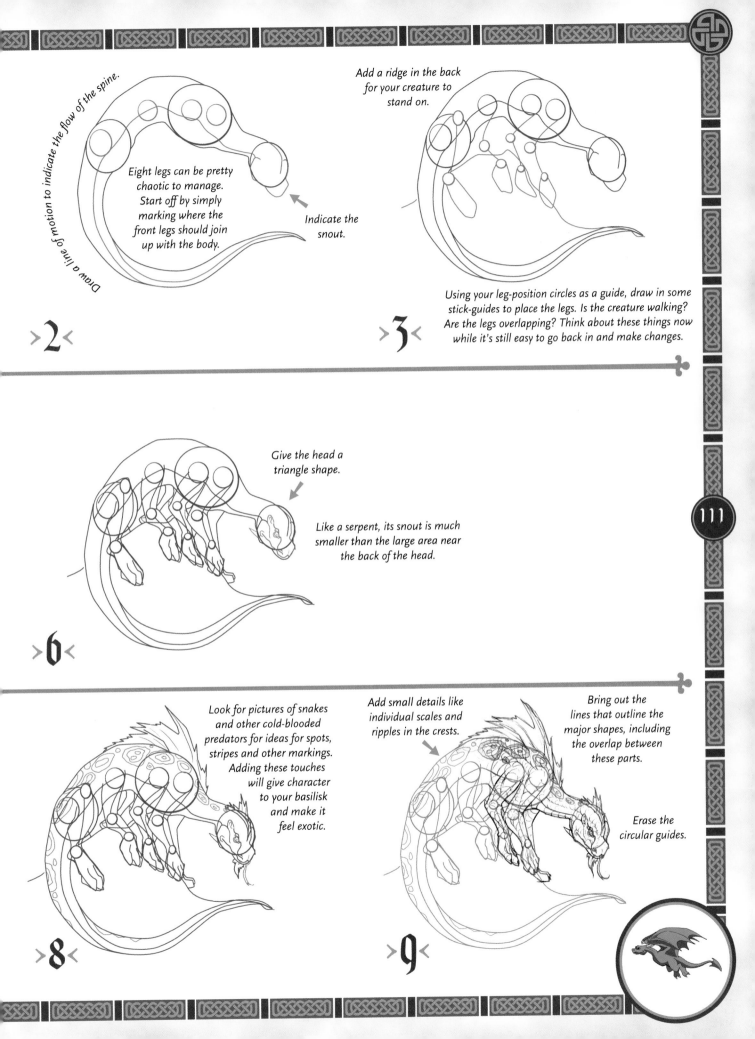

2

Draw a line of motion to indicate the flow of the spine.

Eight legs can be pretty chaotic to manage. Start off by simply marking where the front legs should join up with the body.

Indicate the snout.

3

Add a ridge in the back for your creature to stand on.

Using your leg-position circles as a guide, draw in some stick-guides to place the legs. Is the creature walking? Are the legs overlapping? Think about these things now while it's still easy to go back in and make changes.

6

Give the head a triangle shape.

Like a serpent, its snout is much smaller than the large area near the back of the head.

8

Look for pictures of snakes and other cold-blooded predators for ideas for spots, stripes and other markings. Adding these touches will give character to your basilisk and make it feel exotic.

9

Add small details like individual scales and ripples in the crests.

Bring out the lines that outline the major shapes, including the overlap between these parts.

Erase the circular guides.

Begin the background with some simple triangle shapes to indicate the cave roof and break the ground into simple rock shapes for the floor.

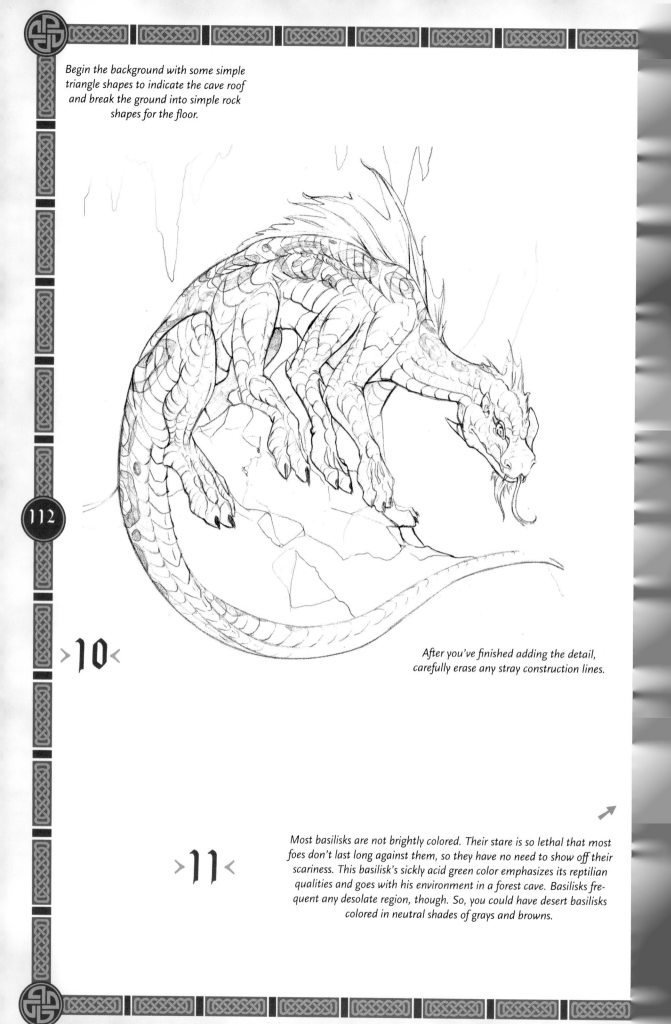

>10<

After you've finished adding the detail, carefully erase any stray construction lines.

>11<

Most basilisks are not brightly colored. Their stare is so lethal that most foes don't last long against them, so they have no need to show off their scariness. This basilisk's sickly acid green color emphasizes its reptilian qualities and goes with his environment in a forest cave. Basilisks frequent any desolate region, though. So, you could have desert basilisks colored in neutral shades of grays and browns.

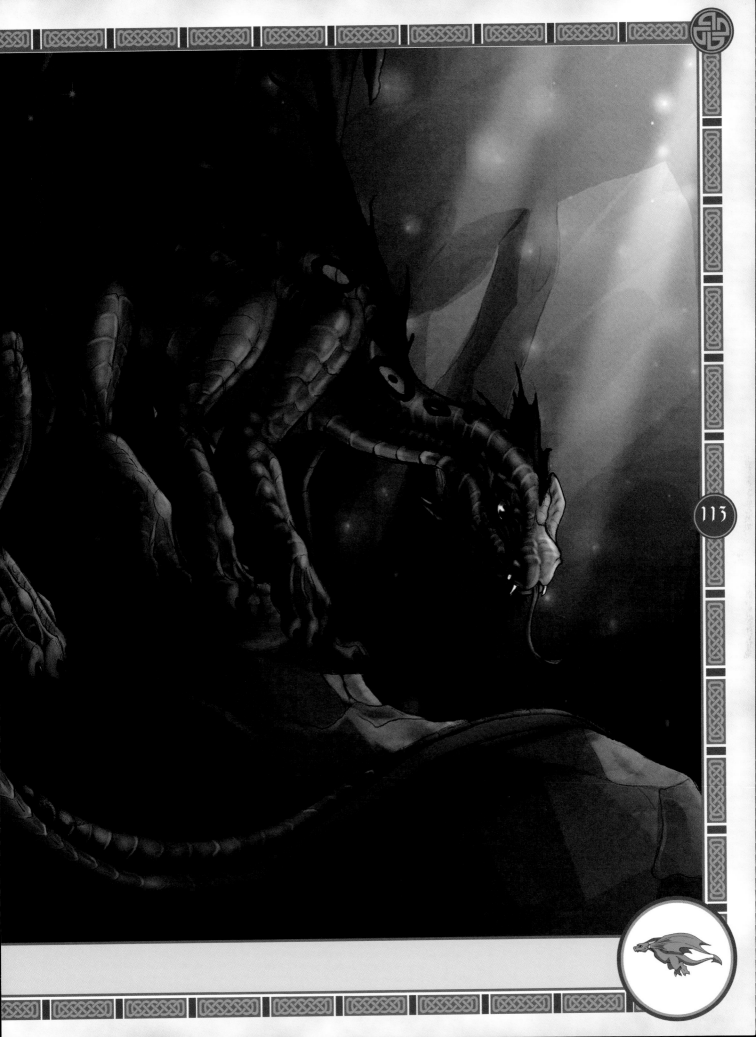

WYVERNS

Though it is cousin to the dragon, any dragon will tell you that a wyvern is not a dragon. First of all, wyverns are not terribly smart and they are rarely beautiful as dragons tend to be. They are pretty nasty critters though, and remain a long-standing fantasy staple.

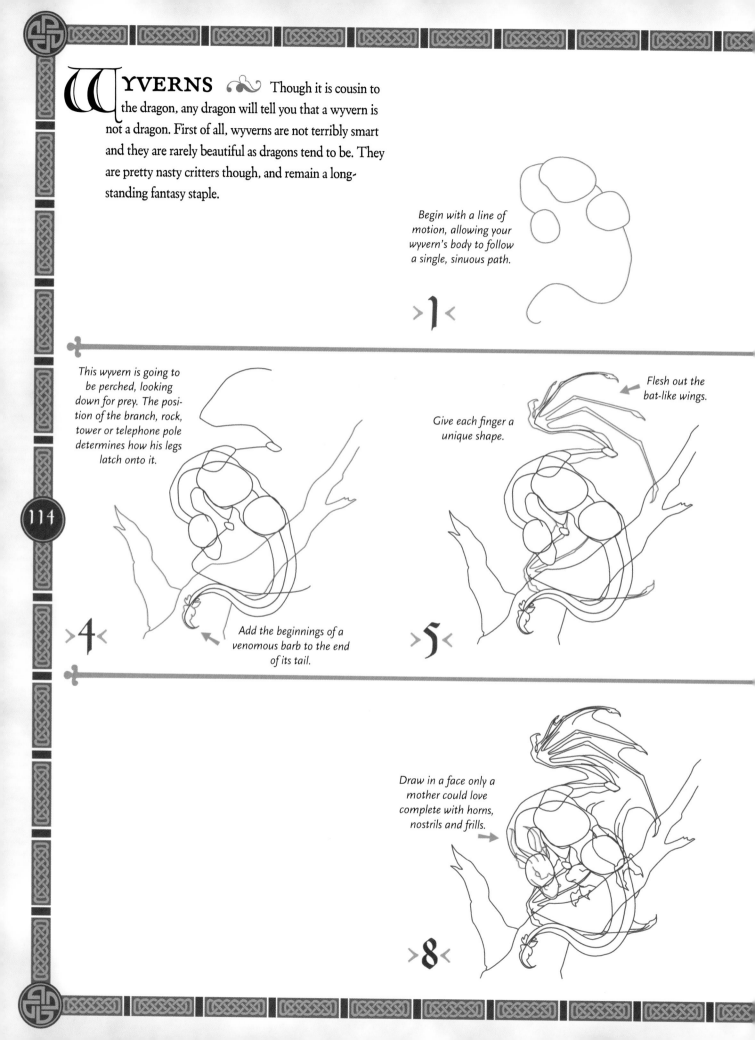

Begin with a line of motion, allowing your wyvern's body to follow a single, sinuous path.

> 1 <

This wyvern is going to be perched, looking down for prey. The position of the branch, rock, tower or telephone pole determines how his legs latch onto it.

> 4 <

Add the beginnings of a venomous barb to the end of its tail.

Flesh out the bat-like wings.

Give each finger a unique shape.

> 5 <

Draw in a face only a mother could love complete with horns, nostrils and frills.

> 8 <

114

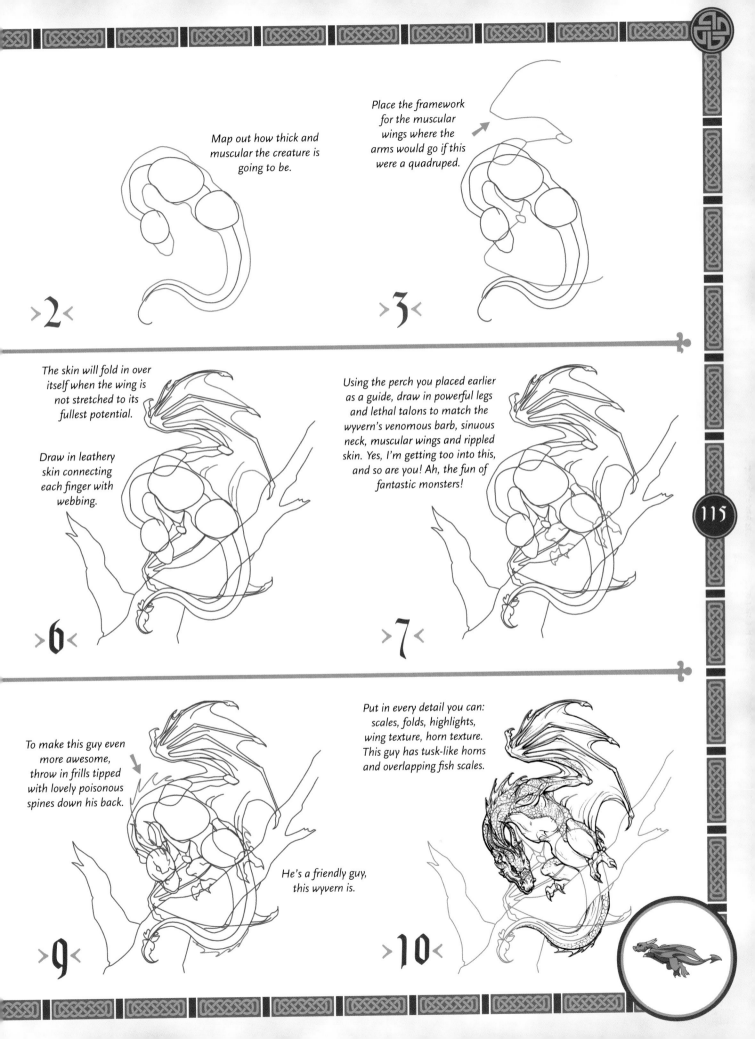

Map out how thick and muscular the creature is going to be.

>2<

Place the framework for the muscular wings where the arms would go if this were a quadruped.

>3<

The skin will fold in over itself when the wing is not stretched to its fullest potential.

Draw in leathery skin connecting each finger with webbing.

>6<

Using the perch you placed earlier as a guide, draw in powerful legs and lethal talons to match the wyvern's venomous barb, sinuous neck, muscular wings and rippled skin. Yes, I'm getting too into this, and so are you! Ah, the fun of fantastic monsters!

>7<

To make this guy even more awesome, throw in frills tipped with lovely poisonous spines down his back.

He's a friendly guy, this wyvern is.

>9<

Put in every detail you can: scales, folds, highlights, wing texture, horn texture. This guy has tusk-like horns and overlapping fish scales.

>10<

OOOOoooooOOOoo, he's textury! Erase his construction lines carefully once you've finished adding all his texture detail.

>11<

In the wild, poisonous creatures are very bright, as if to say, "Hey! I'm dangerous!" Lovely acid green complemented by a cherry red barb warns others of this wyvern's lethal nature. Just because he's a roving eating machine doesn't mean he can't have style!

>12<

HOW TO TELL A WYVERN FROM A DRAGON

A dragon is not a wyvern. The way to tell the difference is fairly simple. A wyvern has two legs and two wings, does not breathe flames and usually has a barbed tail. All these conditions must be met in order to qualify the creature as wyvern-kind. If your "dragon" happens to have a couple of these traits, it's just a dragon variation and not a wyvern. For example, though I have two legs and two wings, I am not a wyvern because I breathe fire and have a traditional spade tail.

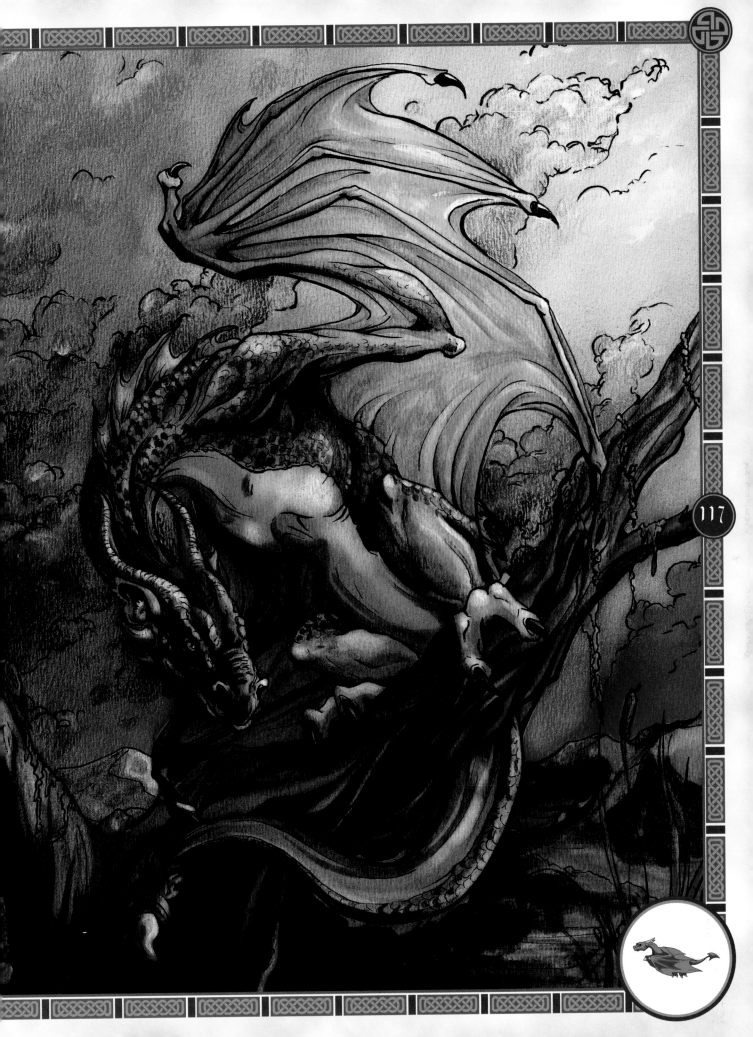

117

SEA SERPENTS

Back when the world was flat, the sun revolved around the earth and the sea was largely unexplored, there were *great big serpents* that crushed entire ships, just for the heck of it. These giant serpents accounted for half of the ships lost and never heard from again. (Of course it was the serpents! Not, um, storms, scurvy, lead poisoning or pirates.) While they may not be quite as cool as pirates, sea serpents are still impressive to draw.

Draw a smooth, curling line of motion to set up your drawing. The sea serpent is basically an oversized snake—very long and very thin.

Indicate the head and rib cage.

> 1 <

Fins make the serpent look aquatic rather than like a giant snake.

Draw out the meaty portion of the fin, extending it out where a land creature's shoulder would be, above and behind the rib cage.

> 4 <

Put gills in the ribs or the neck.

Finish the fins with a sail of skin extending off from the main arm.

> 5 <

Add crests on either side of the head.

Connect the branches of the tail with a sail of skin.

> 7 <

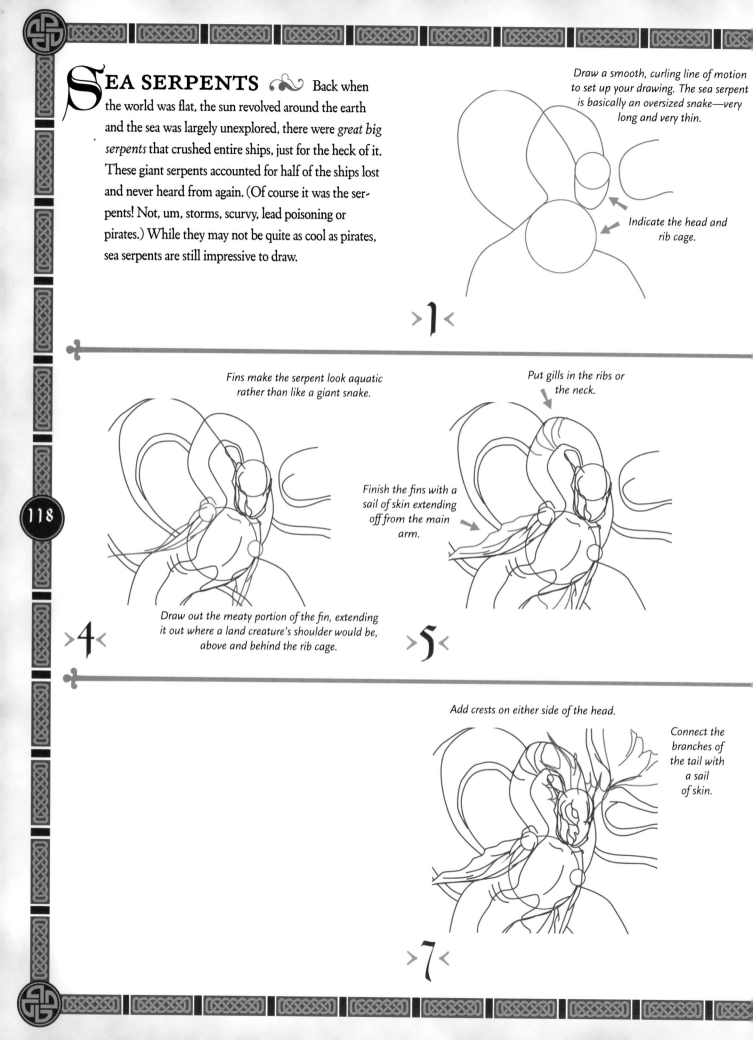

Draw an outline to show thickness.

Follow the line of motion and consider how the coils twist as you draw the edge separating the underbelly from the back scales

Separate a jaw from the main skull.

Pop out the rib cage a bit to emphasize the muscular chest.

An open mouth looks more ferocious. This critter would love to chew on Ahab.

Overlap coils to show the creature's size and give the picture depth.

>2<

>3<

This serpent has a dolphin-like fin to complete the tail. Start by branching the tail into two parts.

Place eye sockets, eyes and a beak to finish the face.

>6<

Add another frill, a long, serpentine tongue and some bone work in the skull.

Since sea serpents are always coiling in and out of the water, it's important that their backs look impressive. Add a nice sail to scare the heck out of local sailors.

>8<

>9<

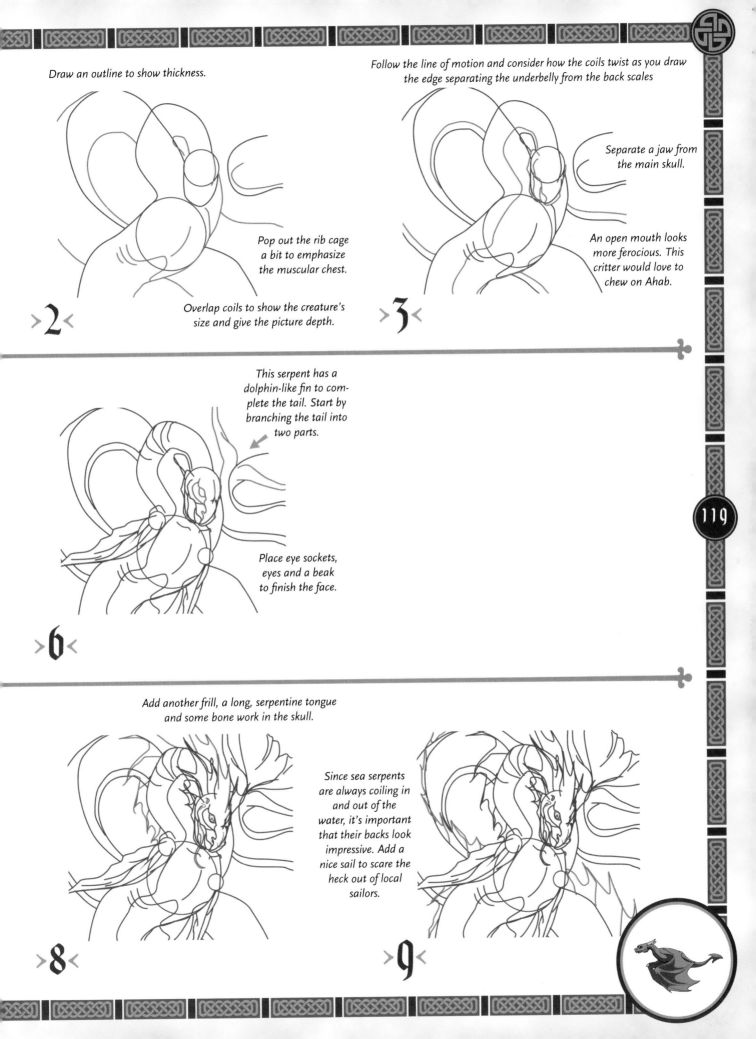

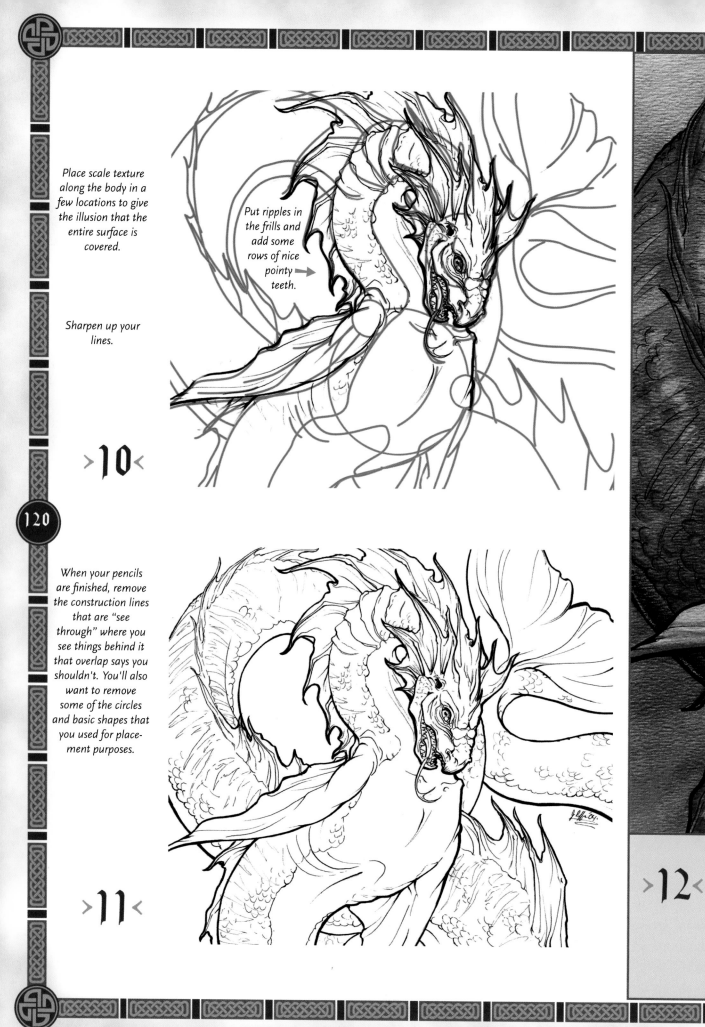

Place scale texture along the body in a few locations to give the illusion that the entire surface is covered.

Sharpen up your lines.

Put ripples in the frills and add some rows of nice pointy teeth.

>10<

When your pencils are finished, remove the construction lines that are "see through" where you see things behind it that overlap says you shouldn't. You'll also want to remove some of the circles and basic shapes that you used for placement purposes.

>11<

>12<

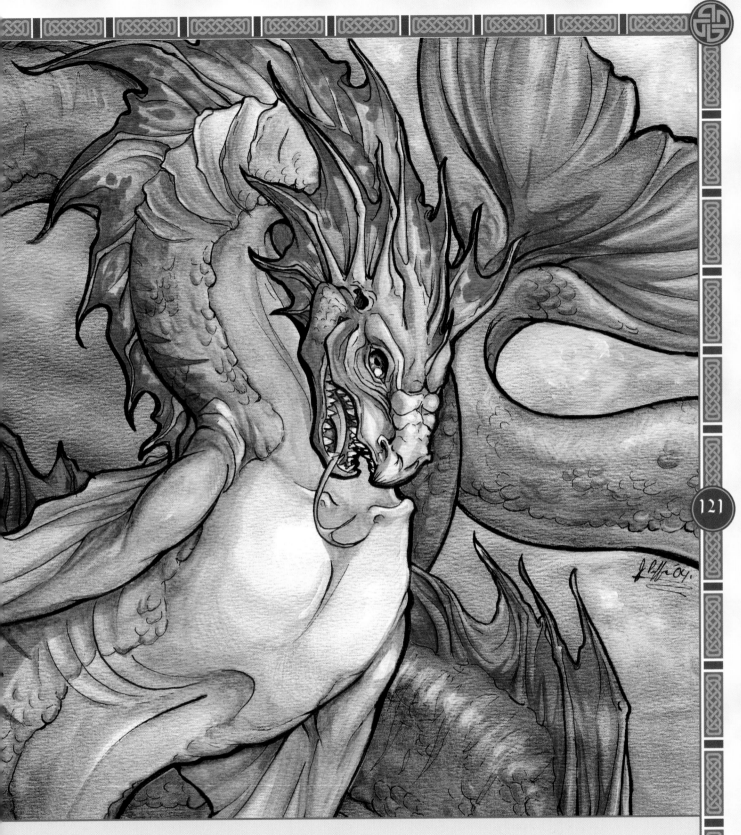

Your serpent may be the color of the sea to blend in or it may be brightly colored, like a tropical fish or a sea anemone. Pop in a background and any other accents you like—a reef, a destroyed ship or a little sailor for the serpent to munch on.

CREATE YOUR OWN FANTASTIC CREATURES

You hold in your hands a reference to help you learn specific creature techniques and anatomy. Don't let these demonstrations limit your imagination, though. Drawing books will help you develop the skill, but the originality and the stories behind your characters must come from you.

These stories may come before you draw your creature. Or you may find yourself working for months on a creature before forming any ideas for who this guy is and what he's destined to do. Just remember that this is your fantastic world, so you make the decisions—as quickly or as slowly as you like.
Let your imagination go wild!

CREATE A HISTORY FOR EACH CREATURE YOU DESIGN

Answer the following questions for each of your inventions:

What is its personality?

What does it eat? Does it eat at all or does it live off magic or the belief of people?

How has your creature and others like it adapted to the environment? A desert serpent will probably look very different from a volcanic serpent, a glacial serpent or a sea serpent.

Do the females have different markings than the males?

What is its size relative to the other creatures in your world?

SHARE THE CREATURES THAT LIVE
IN YOUR IMAGINATION

Have an idea for a fantasy story? Why not design creatures for the world setting?

Which creatures are intelligent? ✦ What are the monsters?

What are the pack animals? ✦ What are the predators?

What are the prey?

QUICK GUIDE TO FANTASTIC BEASTS

Here's a spiffy little guide for quick reference and comparisons among the creatures you can draw in this book. It is by no means a complete guide to every fantasy creature out there, though. Fantasy is dragon, but fantasy is also imagination. As such, its boundaries are fluid. Enjoy!

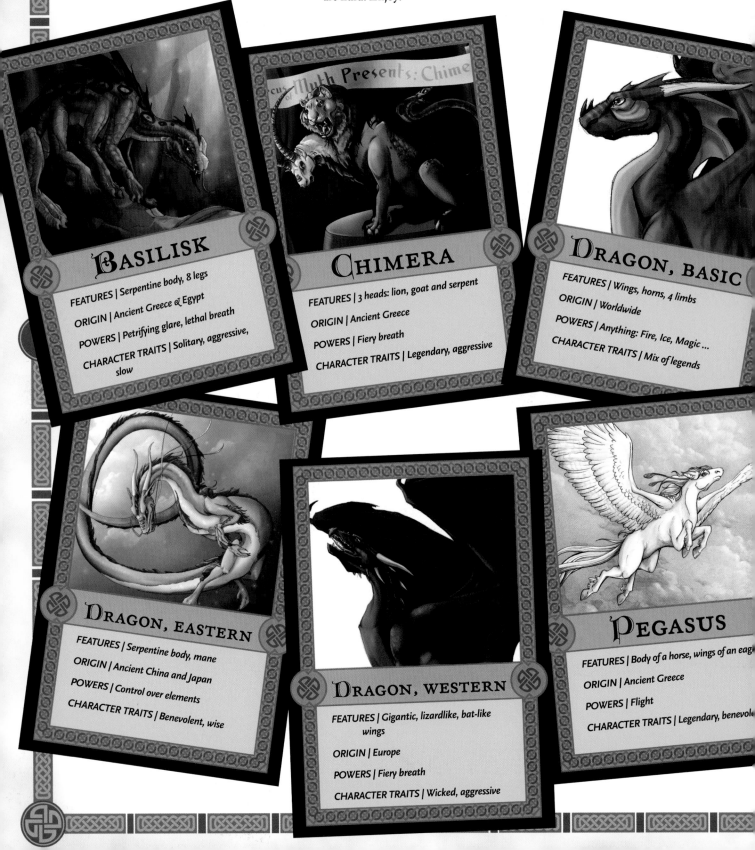

BASILISK

FEATURES | Serpentine body, 8 legs

ORIGIN | Ancient Greece & Egypt

POWERS | Petrifying glare, lethal breath

CHARACTER TRAITS | Solitary, aggressive, slow

CHIMERA

FEATURES | 3 heads: lion, goat and serpent

ORIGIN | Ancient Greece

POWERS | Fiery breath

CHARACTER TRAITS | Legendary, aggressive

DRAGON, BASIC

FEATURES | Wings, horns, 4 limbs

ORIGIN | Worldwide

POWERS | Anything: Fire, Ice, Magic …

CHARACTER TRAITS | Mix of legends

DRAGON, EASTERN

FEATURES | Serpentine body, mane

ORIGIN | Ancient China and Japan

POWERS | Control over elements

CHARACTER TRAITS | Benevolent, wise

DRAGON, WESTERN

FEATURES | Gigantic, lizardlike, bat-like wings

ORIGIN | Europe

POWERS | Fiery breath

CHARACTER TRAITS | Wicked, aggressive

PEGASUS

FEATURES | Body of a horse, wings of an eagl

ORIGIN | Ancient Greece

POWERS | Flight

CHARACTER TRAITS | Legendary, benevole

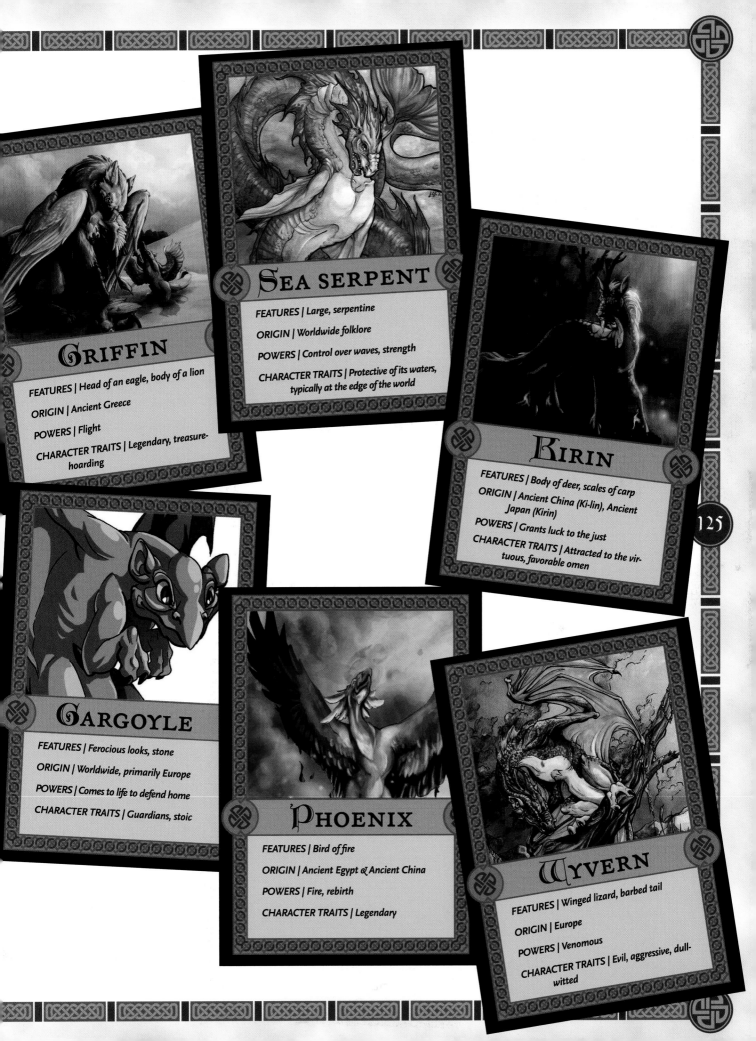

Griffin

FEATURES | Head of an eagle, body of a lion

ORIGIN | Ancient Greece

POWERS | Flight

CHARACTER TRAITS | Legendary, treasure-hoarding

Sea serpent

FEATURES | Large, serpentine

ORIGIN | Worldwide folklore

POWERS | Control over waves, strength

CHARACTER TRAITS | Protective of its waters, typically at the edge of the world

Kirin

FEATURES | Body of deer, scales of carp

ORIGIN | Ancient China (Ki-lin), Ancient Japan (Kirin)

POWERS | Grants luck to the just

CHARACTER TRAITS | Attracted to the virtuous, favorable omen

Gargoyle

FEATURES | Ferocious looks, stone

ORIGIN | Worldwide, primarily Europe

POWERS | Comes to life to defend home

CHARACTER TRAITS | Guardians, stoic

Phoenix

FEATURES | Bird of fire

ORIGIN | Ancient Egypt & Ancient China

POWERS | Fire, rebirth

CHARACTER TRAITS | Legendary

Wyvern

FEATURES | Winged lizard, barbed tail

ORIGIN | Europe

POWERS | Venomous

CHARACTER TRAITS | Evil, aggressive, dull-witted

INDEX

A

Anatomy, 44-45
Angry dragon, 23
Ankle, 36
Arms, 53. *See also* Limbs
Atmospheric perspective, 13

B

Background. *See* Setting
Balance, 58
Basic shapes, 10-11
 anatomy and, 44-45
 box-like, 20-21
 diamond, 21
 for poses, 11
 round or circular, 20-21
 triangular, 20-21
Basics shapes, practice on, 12
Basilisk, 110-113, 124
Bat-dragons, 31
Bellerophon, 90, 94
Belly, 29
Bird anatomy, 44
Blue-Furred Dragon, 83
Body
 back view, 60-61
 front view, 58-59
 side view, 48-49
 3/4 view, 106-109

C

Cat anatomy, 44
Celestial dragon, 66, 70
Cel-style shading, 26-27
Cheekbone, 24
Chest, 16
Chimera, 94-97, 124
Chinese unicorn, 98-101
Claws
 claw-feet, 18
 front, 35
 length of, 39
 talon-like, 40-41
Color
 basics, 55

choosing, 25, 29, 65
 frills, 76
 legs, 35
 meanings of colors, 59
 naturalistic, 97
 varied tones, 49
 webbing, 54
Comic-like dragon, 27
Crosshatching, 12
Cynical dragon, 23

D

Diamond-shaped tail, 80
Dinosaur dragons, 31
Diving dragon, 56
Dolosus, 8
Dragon
 basic, 16, 124
 freedom in drawing, 15
 parts of, 16. *See also* entries
 for specific body parts
 See also entries for specific
 types of dragons
Drake, 64
Dungeons & Dragons, 110

E

Eagle, griffin as part, 106
Earth dragon, 66
Eastern dragon, 66-71, 124
Emotionless dragon, 23
Eraser, kneaded, 10
Expressions, 22-23
Eyes
 emotion and, 22
 highlight in, 28
 position of, 27

F

Fables, 6
Face
 distinctive, 64
 expressions on, 22-23
Fantasy creatures, 6
 creating, 124

Fantasy worlds, 6
Feathers, 82, 90, 102
Feet
 combining types of, 42-43
 See also Claws; Paws
Finger
 with claw, 41. *See also*
 Claws
 with wing, 53
Fins
 dolphin-like, 119
 drawing and placing, 76-77
Firebird, 102-105
Flight, 50-51
Frills
 adding, 18
 drawing and placing, 76-77
 on front limb, 33
Fur
 drawing, 83
 on legs, 99
 mane, 68-69
 on tail, 68, 81, 99

G

Gargoyle, 86-89, 124-125
Goat head on Chimera, 94-97
Griffin, 106-109, 125

H

Hands, 18, 33
Happy dragon, 23
Harry Potter series, 6, 110
Hatching, 12
Head
 crests on, 118-121
 front view, 26-27
 multiple. *See* Chimera
 side view, 24-25
 3/4 view, 28-29
Hide, 33
Highlights, 26-27
Hooves, 91
Horns
 adding, 18
 deer-like, 98-101

as defining detail, 17
 drawing, 24-26
 long, tusk-like, 75
 with skull, 47
 spiral, 74

I

Ice dragon, 65
Imperial dragon, 66
Inking, 39
Intelligent dragon, 32

J

Jaw, 24, 27
Joints, 35

K

Kirin, 98-101, 125
Kit (griffin young), 108
Knee, 36

L

Laughing dragon, 23
Legends, 6
Legs. *See* Limbs
Light source, 12
Limbs
 animal-like front, 34-35
 back, 30, 36-37
 basic approach, 30
 bat dragon, 30
 dinosaur dragon, 30
 front, 16, 30, 32-35
 human-like front, 32-33
 muscular detail, 36, 47
Line of motion, 16-17, 62, 66
Line weight, 25
Lion
 griffin as part, 106
 head on Chimera, 94-97
Lion-like paws, 38-39
Lion-lizard hind paws, 42-43
Lips, 24, 28
Lizard anatomy, 45

Lord of the Rings, The, 6
Lycia, 94

M

Mane, 92, 99
Markers, 39
Markings, 19
Medusa, 90
Mouth
 expression and, 22
 line of, 24
 lip around, 28
Mythology, 6, 85

N

Neck
 fleshing out, 29, 49
 line along, 24
 muscular, 49
 size of, 27
 width of, 49
Nose, in foreground, 26
Nostrils, 24, 48

O

Overlap, 13, 48

P

Paper, 10
Paws
 front, 18
 lion-lizard hind, 42-43
 lion-like, 38-39
 plantigrade vs. digigrade, 38
Pebbled scales, 78
Pegasus, 90-93, 124
Pelvis, 47, 48
Pencil
 shading techniques, 12
 use of, 10
Pens, types of, 39
Perseus, 90
Personality
 color and, 65
 markings and, 19

Perspective, 13
Phoenix, 102-105, 125
Plates, 26
Poison barb tail, 81
Poses, basic shapes for, 11

R

Rib cage, 48
River dragon, 70-71

S

Sad dragon, 23
Sandman comics, 6
Scales, 78-79
 on belly, 25
 carp, 98-101
 on front limb, 33
 hard and shiny, 27
 types of, 78-79
Scribble, 12
Sea serpent, 118-121, 125
Serpent
 head on Chimera, 94-97
 sea, 118-121, 125
 See also Basilisk
Setting
 backlit, 101
 clouds and rain, 71
 sky, 71, 93
 specific world, 6
Shading
 fur, 83
 pencil techniques, 12
 styles, 26-27

Shadows, 26-27
Shapes, basic, 10-11. *See also*
 Basic shapes
Skeleton, 46-47
Skull, 24, 47
Sleeping dragon, 23, 56
Snout, 16
Soft shading, 26-27
Spade tail, 81
Spikes, 18, 26, 33
Spine, 47
Spirit dragon, 66, 7
Stare, lethal, 110
Stipple, 12
Sweet spots, 75
Symmetry, 58

T

Tail
 fur on, 68, 81, 99
 muscular, 49
 ox, 98-101
 Pegasus, 92
 sleek, for balance, 48
 snake, 94-97
 tapered, 16, 62
 types of, 80-81
Talons, 37, 40-41
Teeth, 47
3-D effects, 12
Toes, 42-43
Tools, 10
Treasure hoarder dragon, 66,
 70

U

Unicorn, Chinese, 98-101

W

Walking dragon, 56
Web site, www.neondrago-
 nart.com, 3
Western dragon, 62-65, 124
Whiskers, 68-69
Wind spirit dragon, 70
Wing
 back, 18
 back view of, 60-61
 bat, 52-53
 connection points for, 50
 curved or overlapped, 54-55
 feathered, 82
 flight and, 50-51
 folded, 56-57
 framework for, 62-63
 gargoyle, 87
 muscles in, 47, 54-55
 muscular, 31
 open, 52-53
 operation of, 17
 Pegasus, 90
 Phoenix, 102-105
 size of, 51
 skeleton, 46
 webbing, 19
Wyvern, poison barb tail on,
 81, 114-117, 125